MARITIME ~~TALES~~

of

LAKE
ONTARIO

Susan Peterson Gateley

THE
History
PRESS

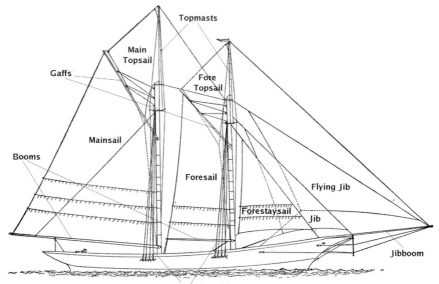

Topmasts

Main
Topsail

Gaffs

Fore
Topsail

Mainsail

Booms

Foresail

Flying Jib

Forestaysail

Jib

Jibboom

Shrouds

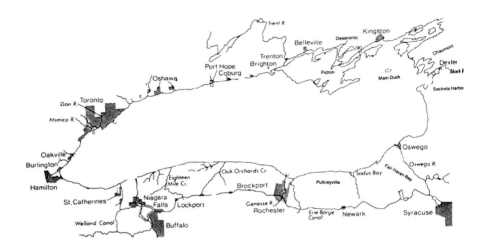

Published by The History Press
Charleston, SC 29403
www.historypress.net

Cover painting by Peter Rindlisbacher.

First published 2012

Manufactured in the United States

ISBN 978.1.60949.684.5

Library of Congress CIP data applied for.

"A Young Boy's Prayer,"
by Sally Hendee

When he was but a boy, he stood upon the great sea's shore.
He said a prayer that he would, one day, share the vast realm's lore.

"Be careful what you ask" old fisherman once said.
"Too many have been called by him—now neath him they lay dead.

Many young a noble hearts were stilled in dark and deep—
Unfinished lives whose bones shift with the tide but never sleep."

The young boy ne'er spoke those words again—at least not said aloud.
But silently the wish went on—a quiet one he vowed.

He thought the old man foolish for his words about the sea—
Perhaps his age had taken all the dreams that set him free.

"Take me, Take me" young man said, "to some great distant shore.
I'd rather be out in the sea, than landed evermore."

He visited that changing beach until he was a man,
shouting mutely at the tides, he is still, restless, boy demands.

Then came the day he thought dreams had come to pass—
freeing him of grounded duties—even his faire lass.

Old man who warned him long ago had gone since that first vow.
The young man knew the time to venture seaward would be now.

He fit his life into a bag that he hung over his shoulder,
finally took steps he would have years ago if bolder.

He turned, looked back with his last few steps from land.
With left arm holding all he owned, he waved with his right hand.

On the pier stood a lovely girl with her endless, salt tears flowing,
who could not stop the man she loved so very much from going.

Did he remember the parting scene as ship pulled from all he knew?
Was that fleeting feeling worth his life that now was through?

For almost as soon as ship had cleared all sight of land,
a great storm shivered every timber, till it rested in sea floor sand.

No more longing of boy's prayers run in his years.
No more would he see his sweet girl's mournful tears.

He finally got his life long wish to be part of sailor's lore
for now he rests, his bones unmarked, on deep, dark ocean floor.

CONTENTS

PREFACE AND ACKNOWLEDGEMENTS

S hipwrecks are part of Lake Ontario's history. But so are innovation, wealth building, heroism and bungling on a grand scale. You'll find examples of each of these actions in this collection of historic incidents and personalities who once worked on and by the waters of this Great Lake between 1728 and the present.

I've never been involved personally with a real shipwreck. But many years ago, nature gave me a hint of what it feels like. My small sailboat and I were running for shelter, trying to beat an oncoming thunderstorm. I was about one hundred yards from the bay shore on a sultry summer evening when the squall struck. I had taken my sails down and had the throttle wide open on my three-horse outboard as I scurried toward the shelter of the land when the first gust slammed us. It immediately shoved the bow of my boat off course and turned me broadside. My boat heeled sharply under bare poles as the windage of her rigging and mast acted as a sail. The wind then got under the boat's bottom, flipped her over and dumped me in the drink. My little outboard was still running when it and I hit the water.

As I paddled around the capsized boat in the warm bay (in an uncharacteristic fit of foresight, I had put my life jacket on previously), I kept saying out loud, "I don't believe this!" Things had gone out of control in a moment. I found it difficult to swim against the wind and six-inch chop. Unnerved, I grabbed the stern and hung on. Within minutes, I was rescued and my swamped boat taken in tow by a sympathetic cottager with an

outboard skiff who had watched the whole fiasco. I was told afterward that a nearby anemometer registered a seventy-mile-per-hour gust.

My "shipwreck" was short-lived. The only damage was to my ego, and the only loss was that of my boat's rudder. Since then, I've ducked other summer squalls as I've tried to avoid trouble on the big lake. Others have been less successful. A couple of years ago, a fellow drowned in seven feet of water in Sodus Bay. He had gone overboard on a fine sunny spring day on purpose to free a fouled prop and underestimated how cold the water still was.

I've never found a victim's body either, though I know people who have. I am a summer sailor, and most of the shipwrecks I've seen would more properly be termed mishaps. I once saw an upside-down helicopter that was kept up by its landing pontoons. The crew had all been rescued hours before. I walked around a friend's beached twenty-two-foot sailboat near Pultneyville that had drifted ashore after the rudder broke and have observed derelict wrecks abandoned on the shores of a couple of Caribbean islands. Accidents do happen—usually very quickly.

The subject of shipwrecks depresses most sailors, who try hard to keep the side of the boat with the sticks on it pointing up. But shipwrecks make for compelling literature, and the events before, during and after a wreck can be educational. Shipwrecks, unlike plane and car crashes, are also often fairly drawn-out affairs. The *Titanic*, whose end still fascinates us one hundred years later, took two hours to sink. This allows ample time for all sorts of intense human action and interaction. We are still fascinated by the story of the *Titanic*'s end and that of her passengers and crew. Lake Ontario, thankfully, never lost a large passenger steamer like the *Titanic* in open water. But smaller disasters just as gruesome occurred here. The end of the steamer *Ocean Wave* that burned off Prince Edward County on a cold April night in 1853 comes to mind. About seventeen of the twenty-three passengers died in the fire fueled by the wooden hull and the melted butter cargo that ran in flaming torrents off the ship's sides.

I believe we should preserve historic shipwreck literature for the lessons it teaches about the lake and our relationship to it. The lake is often overlooked by non-boating residents and policy makers in the region, yet it still matters. It's still important, and not just to south shore fruit farmers or town tax assessors. Once, thousands of people with transportation industry jobs made a good lake-related living here. Today, lakeshore real estate development and energy production continue to produce profits. So why write a book about nineteenth-century shipwrecks? They are grim reminders of the limits of technology. Though we no longer move cargo around the lake with engineless

schooners, today's transportation and energy production systems can still fail. Lake Ontario, with its shoreline fleet of aging nuclear reactors, could be the scene of the next Fukushima nuclear meltdown. We are blessed with some of the oldest commercial nukes in North America here on the lake.

Shipwrecks, simply because they were so unusual, were well documented in their time. What is not told to us is the aftermath. The hardship and suffering of families left without a father or brother or son were just part of the deadly grind and not newsworthy. There was no social security widows' benefit back then. Kids took full-time jobs and did hard labor at age ten or twelve to help keep the family afloat. In 1879, the two-year-old schooner *Jenkins* went down with all hands fewer than twenty miles from her home port of Oswego on her last trip of the year. Her loss hit the community hard. At least ten children were left fatherless, and efforts were made to help the families get through the winter. The loss of the *Jenkins*, owned and crewed by so many of Oswego's men, prompted the local paper to appeal for the formation of some sort of formalized charity program to aid the families of lost sailors. And a ballad was soon composed for the tavern-goers. It concludes:

> *For beneath Ontario's heaving billows,*
> *Those brave men now are safe to rest,*
> *Sleeping on their rocky pillows*
> *Beneath the cold waves' stormy crest…*
>
> *When the snows of winter fast are falling*
> *And Hunger stands at the widow's door*
> *Remember charity is your calling,*
> *And he who gives will have the more.*

Today, the intensity of our relationship with the lake is trivial compared with that of the nineteenth-century mariner. We Sunday sailors venture forth only on summer waters. They sailed from April ice-out until mid-November, when insurance coverage generally ceased. Many of the schooner captains owned an interest in their ships. And sometimes these entrepreneur/master mariners had hardscrabble years. After the Civil War, an economic bust hit the Great Lakes region. Back then, there were no unemployment insurance benefits or 401k plans to raid. During the 1870s, accounts of suicide among schooner captains were far from rare in the Oswego newspaper. Sometimes a captain hanged himself in the night aboard his own ship.

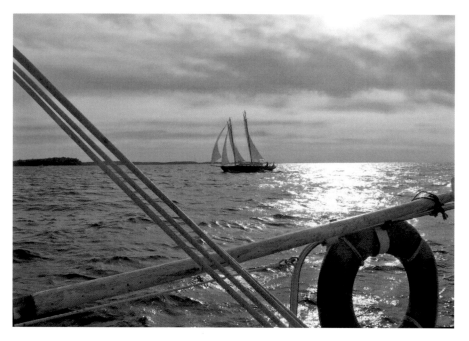

The lake is large and cold and deep. Even today, those who sail on it for pleasure must remain respectful of its power. *Author's collection.*

Yet the successful ones, and there were many, took great pride in their profession. They kept their vessels shipshape and trim as best they could, and many of the smaller two-masted schooners were family affairs crewed by sons or nephews of the captain-owner. A few wives sailed aboard as cooks, too. And almost certainly more than one new bride sailed on a honeymoon cruise to a south shore coal trestle, as Mrs. John Williams did aboard her husband's ship, the *W.T. Greenwood*, back in 1885.

The best lake captains had a mix of boldness, caution and good judgment. Quick and decisive action may be better than doing nothing. Crowding on sail and getting into port before the storm hits works sometimes, but not always. That's where the skill, intuition, experience and fast reactions come in. There's no time to weigh the various options. Sometimes you just have to act. Skill and experience increase the odds that you'll act right, but the good skippers never take the water for granted. Then, as now, the competent captain saw to the care of his ship and her crew while in port. He kept up on preventative maintenance and repaired the small problems before they got big. If a pin came adrift or a lashing let loose on the lake, men could die.

Nature is not to be taken lightly. As we tamper with and tear at the web of life and even contemplate geo-engineering our weather and climate, it's worth considering the fact that we are not gods. We are part of that thin skin of life that wraps our planet like a membrane. We fool around with it at our peril. The resilience, skill and sheer toughness of the lake's hardy mariners is to be admired and celebrated. But at the same time, we should heed the warnings of history. Like them, we are part of and subject to the natural laws of this intricate and wondrous creation. We must live with it and use its life-giving resources wisely.

ACKNOWLEDGEMENTS

I have drawn heavily on and owe much to two Canadian sailors for their work to preserve history. They are C.H.J. Snider and Robert Townsend, both of whom have now passed over the bar to that final anchorage. Snider published several books on Lake Ontario history and also wrote 1,300 columns under the heading of "Schooner Days" for the *Evening Telegram*, a daily newspaper in Toronto where he served as a reporter and then as an editor for many years. These were published between 1931 and 1956. Snider, in his younger days, sailed "before the mast" in several lake schooners and was a lifelong yachtsman who cruised on all the Great Lakes with his own boats. He knew how to dig out data from archives, too, thanks to his news-gathering days.

Robert Townsend was a lawyer and a yachtsman who sailed on blue water and lived for many years on the Bay of Quinte. He was a principal in the founding of the Mariner's Park Museum on South Bay in Prince Edward County. His keen interest in the area's marine heritage led him to create a database of all the "Schooner Days" columns, and he compiled and edited a number of them to produce three full-length books. Like Snider, he left a grand legacy for those of us with an interest in the lake's nautical past.

I also must express my appreciation to Richard F. Palmer for sending along some of the photos used in this book and for sharing a copy of Captain Van Cleve's *Reminiscences*. Palmer has published several works on nineteenth-century transportation on land and sea. His latest work, *On the Waterfront: Maritime Life in Oswego and Lake Ontario*, was published in 2011. And thanks also to Paul Truax for his help on the La Force story and to

Walter Lewis for his help in both facts and artwork from his website, www. maritimehistoryofthegreatlakes.ca. Several other writers, sailors and, last but not least, one husband also were of great help in the completion of this work.

THE LAKE DECLARES WAR

Lake Ontario played a major role in three nineteenth-century wars. In the North American front of the Seven Years' War between France and England (usually termed the French and Indian War in U.S. history books), the Revolutionary War and the War of 1812, the St. Lawrence River and Lake Ontario were crucial water routes for rapidly moving men, heavy field artillery and supplies to battles and to western forts. There were no good all-weather roads then, and an army could spend weeks slogging and chopping its way through mud and tangled windfalls of the forest to travel one hundred miles. On the water, the men and their gear could move the same distance in twenty-four hours. Control of the lake was vital, and in each conflict, the combatants built navies on the spot to achieve that goal.

Some of the worst losses of life during naval activity here were the result of weather. The neutral, uncaring lake waged war on the unprepared no matter what their nationality. A key American defeat in battle during the War of 1812 may have been affected by a Lake Ontario storm, and the worst casualties during naval action of that war on the lake occurred during a summer squall. Thirty-five years before that, a British ship transporting men and gear from the Niagara front during the Revolutionary War was sunk by a Halloween gale with the largest loss of life ever to occur during an open-lake shipwreck on Lake Ontario.

The War of 1812 has been called the forgotten war, and at least in upstate New York on the south shore of the lake where I live, that seems to be a fair assessment of the conflict. As I write this in the war's first bicentennial

year, many of the reenactments and festivals scheduled to commemorate it appear to be Canadian. It's a war that both sides claim they won (which may not be such a bad thing), and while the young republic of the United States of America had plenty of legitimate gripes over its relationships with the British—such as impressment of its seagoing sailors into the short-handed British navy—the war was not particularly popular initially on either side of Lake Ontario. Free trade was important to residents of both sides of the lake, and the Embargo Act of 1807 that prohibited trade with England in the run-up to the war was promptly and widely violated with plenty of smuggling across the lake. When war was finally declared, the so-called blue-light Federalists who were opposed to it had a local presence. Ned Myers, a navy recruit, and his shipmates encountered a fair amount of hostility among farmers in the region as they traveled to Sackets. When as a prisoner of war he and his crew were marched from the west end of the lake to Kingston, several Canadians offered food and comfort to the luckless American sailors. Snider wrote in his centennial commemoration of the war, *In the Wake of the 1812ers*, that as late as 1814, the British actually bought white pine for the masts of their naval ships being built for service on Lake Champlain from Yankee lumbermen who were perfectly willing to make a profit when and where they could.

Initially, the Americans thought that a large number of Canadians would rally to their cause. This decidedly did not occur. The first few skirmishes on and by the lake were fairly low-key and resulted in little bloodshed. I have written of one, the first battle of Sackets Harbor, in *Twinkle Toes and the Riddle of the Lake*. In this comic opera affair, the local militia was able, with a single lucky shot from its land-based cannon, the Old Sow, to repulse an attack by a small fleet of warships. It was one of the first shots of the war. Things soon got bloodier, however, and by 1813, hopes for a quick finish to the war had dimmed. It was now very apparent that the Americans weren't simply going to march unopposed through Canada to victory. Although Britain was tied up in a life and death struggle with France overseas and so forced to fight a defensive battle on the lake, its soldiers and those of the Provincial Marine and land-based militia were holding their own.

In the summer of 1813, a series of naval engagements took place at the west end of Lake Ontario in which the British and American fleets played cat and mouse with one another for several weeks. It was during this period of indecisive skirmishing that two small naval vessels were sunk by Lake Ontario in a summer squall. It was the largest loss of life of any naval engagement on the lake during the War of 1812. At least eighty men died,

and only sixteen survivors lived to tell the tale of the lake's unexpected and intensely localized fury on the night of August 8, 1813.

We who are intrigued by history's events are fortunate to have an eyewitness account of the sinking of the *Scourge*. Ned Myers was a merchant sailor before the mast who signed up to fight for his adopted homeland against the British on Lake Ontario in the spring of 1813. He had run away to sea from his unhappy foster home in Halifax at age twelve. His life story was published by James Fenimore Cooper, who in his younger days had served with Myers aboard a merchant ship.

Myers was a survivor. He led an eventful life worthy of the most swashbuckling plot of a nineteenth-century maritime adventure novel. He told Cooper that his father left him and his sister when they were young, but Ned believed him to have been a man of good station in class-conscious English society. He had been an army officer and a friend of the Duke of Kent, Prince Edward, who was Queen Victoria's father. Prince Edward acted as godfather to young Ned. Despite an effort by Edward to recruit him to military service, Ned followed his own headstrong way to sea and made several trips to Europe aboard a merchant ship before signing up with the U.S. Navy. After his very close call on Lake Ontario, he went back to sea and helped smuggle tobacco into Ireland and opium into China. He once found himself with two other shipmates adrift in a ship's boat for twenty-six hours before they were miraculously found and picked up by their ship. He was chased by pirates, wrecked on the coast of Ireland and, when ashore, lived the hard-drinking, free-spending life of a deep-water sailor for many years. He told Cooper it was the loss of his first true love that set him off on a lifelong affair with demon rum. She took the engagement ring to a jeweler to be engraved while he went off on a last voyage to make some money for his impending married life. Alas, she fell in love with the jeweler, married him while her sailor was at sea and broke poor young Ned's heart.

He had not yet met his girl when he signed up for naval service and, with his mates, traveled afoot and in wagons over the rough trails and portages that then made up the Albany-to-Oswego overland route. After the recruits reached Sackets Harbor, Myers was assigned to the navy's recently commissioned *Scourge*. The schooner rigged *Scourge* and the *Hamilton* had originally been designed and built as cargo carriers. The *Scourge*, launched in Canada as the *Lord Nelson* and later captured by the Americans, was about sixty feet long and displaced just forty-five tons. The *Hamilton* (built in Oswego originally as the *Diana*) was larger, at seventy-six tons. When they were modified for war, the changes—deck reinforcement, added bulwarks

and heavy cannons and other gear secured on them—raised their center of gravity and made the two vessels dangerously top heavy and "tender." The little *Scourge*'s bulwarks (wooden rails around the deck) were built up, and she was given four six-pounders and four four-pounders weighing several tons to haul around. The somewhat bigger *Hamilton* was equipped with eight twelve-pound carronades, heavy short-barreled guns designed for close range work and a huge long gun mounted on a turntable on her main deck so it could swivel to fire in any direction. One account of the time referred to it as the Old Sow, which was the name of the long thirty-two that had defended Sackets Harbor successfully in the opening naval skirmish on Lake Ontario the year before. A long thirty-two and its carriage weighed over three tons, plus the weight of its shot and other equipment.

Consequently, the two ships were not great sailors and often were towed behind the commodore's flagship, the *General Pike*. In light wind, they were small enough for the crew to man sweeps, long heavy oars, to move them through the water. Myers relates in his account that the schooners' lack of stability was well known, and aboard the *Scourge*, the halyards were usually kept ready for immediate release and lowering of the sails. On the fateful night of her sinking, the wind fell calm and the tired crewmen who had been at battle quarters all day, hauling for hours on the heavy sweeps as they tried to stay in formation and engage the enemy in light and variable winds, were all too ready to splice the main brace, eat their suppers and settle down for some badly needed rest.

Ned Myers recalled that the starlit sky was perfectly clear and the lake was "as smooth as a looking glass." The enemy fleet lay a short distance off, also becalmed. Because the enemy ships were so close and the night was so calm, the captain decided not to secure the guns in the usual fashion but rather to keep them ready for instant firing. The men were to sleep on deck beside their guns. If a breeze were to come up, they could secure them promptly.

Myers was awakened by a few large drops of rain falling on his face. Perhaps a half minute later, he heard a strange rushing noise off in the distance. He had gotten up and was making his way aft in the intense blackness when a flash of lightning and an instant crack of thunder sounded. With it came "a rushing of winds." Myers ran forward to cast off the jib and topsail sheets to spill the wind from the ship's sails. But it was no use. The *Scourge* was knocked down all standing and lay over with her lee side deep under the water as the guns, cannonballs, boxes of grape shot and everything else on deck slid, tumbled and crashed to leeward. This was the fatal blow. Perhaps the ship could have recovered from the knockdown had the guns been secured,

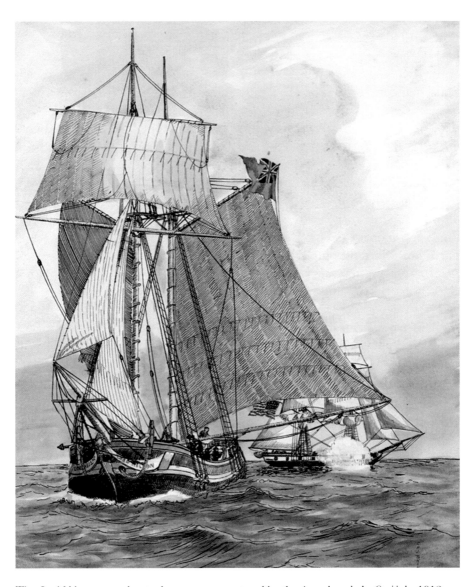

The *Lord Nelson*, a merchant schooner, was captured by the American brig *Oneida* in 1812, as shown in this C.H.J. Snider print, and then was converted to naval service as the USS *Scourge*. *Courtesy of Toronto Public Library, Special Collections.*

perhaps not. But when tons of cast iron slid to the low side, her doom and that of most of her men was sealed.

Amidst the lightning flashes, Myers heard shrieks and cries of men who had been swept to the low side of the boat and jammed or crushed under guns, shot boxes and other gear. After casting off the sheets, Myers pulled himself up the steeply canted deck to the windward side. He glimpsed one of the guns capsized and landed directly over the forward hatch, blocking the exit for the men below. He saw one man struggling to get past it. Amidst an awful and infernal din of thunder, shrieking screaming men and roaring wind, he made his way to the ship's stern. Myers couldn't swim, and when he reached four of the big sweeps secured on deck, he tried to jerk one free of its lashing. The becket broke unexpectedly, and the heavy sweeps all rolled to the low side. He went on aft and saw the water pouring down the companionway as the ship's captain tried desperately to climb out of one of the cabin windows. As Myers hesitated on the very stern of the ship, another sailor clinging to the main boom called, "Don't jump overboard—the schooner is righting."

Myers was a cool customer, and he figured even if she did right herself, she was full of water and would promptly go down, taking her men with her in the suction of her final plunge. He jumped. In Cooper's account, Myers says, "It is my opinion that the schooner sunk as I left her." He was drawn under by the ship but popped up again and, for the first time in his life, began swimming. He hit something solid, which turned out to be the ship's boat. Someone had cast it loose just before the ship went down. "Had I swum another yard, I should have passed the boat, and missed her altogether!" Myers hauled himself aboard, and as another flash illuminated the scene of pouring rain, he saw that the *Scourge* had vanished. He could hear the cries and shouts of the drowning men in the lake around him, and when the lightning flashed, he saw some of their heads. He began sculling around to rescue as many as he could and eventually filled the small boat with survivors, seven in all. The wind had now dropped, and soon the cries and screams began to fade. Ned told Cooper, "I saw many heads, the men swimming in confusion and at random. By this time little was said, the whole scene being one of fearful struggling and frightful silence. It still rained but the flashes were less frequent." Myers kept calling out to the men in the water, hoping to get a few more into the boat. One who answered and swam to the boat was his old messmate Tom Goldsmith, who just ten minutes before had been sleeping beside him. Tom told him the ship had gone down with flying colors, for her pennant had nearly entangled him and taken him

with her. "Davy has made a good haul, and he gave us a close shave: But he didn't get you and me."

Ned and Tom pulled several more men in until the boat was so low in the water they dared not bring anyone else aboard. By this time, the wind had dropped and it was calm again, though the rain was still falling and a deadly silence prevailed. It appeared that all the *Scourge*'s remaining crew had gone down. They began rowing the heavily loaded boat in the hope of being picked up by an American, and soon they found the schooner *Julia*, which took them aboard. Upon hearing of the *Scourge*'s loss, the captain immediately ordered his ship's boat launched to search for more survivors. At length, it returned with four more men aboard, all that was left of the *Hamilton*'s crew.

About eighty men died that night while sixteen were saved. It was the heaviest loss of life in a single naval engagement on Lake Ontario, and it was the lake that night that went to war. Ironically, the *Julia*, perhaps less than a mile away from the *Scourge* and *Hamilton*, experienced only a bit of wind and heavy rain. The next day, the squadron passed through sponges, gratings, sweeps hats and other articles floating about. A sharp lookout for additional survivors was kept, but no more were found. The lake had swallowed up two ships and most of their crews. Myers wrote, "The *Scourge*, as had been often predicted, had literally become a coffin to a large portion of her people."

ANOTHER BLOW AGAINST THE AMERICANS

Luck and chance play roles in most battles. The events at the Battle of Cryslers Farm, said by some to be a turning point in the war, were no exception and appear to have been influenced, if not determined, by events on the lake a few weeks before. The Americans were defeated at Cryslers Farm by a much smaller force of defenders.

Late in the summer of 1813, a decision was made to launch a two-pronged attack on Montreal, a key fortification on the St. Lawrence. One army of five thousand men under General Wade Hampton would make its way up the Lake Champlain route, while the second under Major General James Wilkinson with eight thousand men would travel across Lake Ontario and then down the St. Lawrence. The armies would meet at Montreal. Opposing them with much smaller forces were several British units and the local militia, so the odds looked pretty good for an American victory. If

Montreal did fall to the Americans, they would control the vital supply line of the St. Lawrence and the lower Great Lakes. Canadian opposition in the interior of the continent would soon wither, and the war would be won.

However, Wilkinson's portion of the offensive got off to a bad start. For one thing, Wilkinson and the other American general, Wade Hampton, hated each other. Hampton was from South Carolina and, one account says, "possessed a boundless sense of his own self importance." He was a strict disciplinarian known to beat a poor performing soldier with a hickory cane. Wilkinson, on the other hand, had a reputation for disloyalty and intrigue. One source says he saw his appointment to command the invasion force as a chance to redeem himself and his badly tarnished reputation. Another historian quoted on Wikipedia says, "He was a general who never won a battle or lost a court marshal [*sic*]."

Wilkinson had led a checkered life of intrigue that historians argue over to this day. Some say he was clearly a traitor to the new republic of the United States of America immediately after the Revolutionary War and that he may have conspired with Aaron Burr to carve out an independent fiefdom on the western frontier where Kentucky lies today. Yet others point out that he had the unwavering support of Washington and Jefferson and that he was hauled into court several times only to be cleared of all charges of treason. It's even been suggested that he was acting as a double agent in his younger days of service as a statesman and military commander. He may have been a spy and a drunk and a failure as a military man. Some say he was a murderer, too, and may have done in Meriwether Lewis of Lewis and Clark fame. Yet one account of his efforts in Kentucky on behalf of its residents as he sought statehood suggests that while he was certainly interested in making money, he may also have been trying to serve the general good as he stood up for the rights and welfare of the frontiersmen and farmers. One thing seems pretty clear from even a cursory reading of Wilkinson's life: he had a fragile ego and a hot temper. Just what really lay behind his smooth charm and touchy disposition we will never know.

Because of the animosity the two American generals held for each other, the planning and execution of the invasion did not go well. Wilkinson and Hampton refused to communicate directly, and the run-up to the attempt on Montreal reads a bit like waging war by committee. Plans were made, changed and then changed again, and communications were sporadic and perhaps garbled as delays mounted. For weeks, the Navy Yard at Sackets had bustled with activity as dozens of flat-bottomed bateaux and Durham boats (larger versions of the bateaux, long, narrow, double enders capable of carrying about

The Sackets Harbor Navy Yard during the War of 1812 was one of the busiest in North America, with thousands of men stationed at the base. *Artwork from Lossing's* Pictorial Field Book of the War of 1812.

seventeen tons on a twenty-eight-inch draft), some armed with small cannon, were knocked together by gangs of boat carpenters. The invasion fleet and its personnel were ready on October 4. Yet, writes Benson Lossing in his *Pictorial Field-book of the War of 1812*, "final orders were not issued until the 12th, when a plan of encampment and order of battle was given to each general officer and corps commander, to be observed when circumstances would permit. Four days more were consumed without any apparent necessity, when, on the 16th, orders were given for the embarkation of all the troops at the harbor destined for the expedition." By the time Wilkinson's force finally did shove off for the St. Lawrence, it was an army of men that by most accounts were not well trained. And the lake was waiting.

Because men and gear from several areas were to be gathered together for the trip downriver, Wilkinson ordered that Grenadier Island, a large island near Cape Vincent and about eighteen miles from Sackets Harbor, was to be a staging area. From here, the entire force would move together down the St. Lawrence. But things did not go according to plan. Presumably to keep the large troop movement unobserved by spies, the forces set out in darkness, their small, low-sided boats crammed with ammunition, ordnance, hospital stores, camp gear and two months' worth of provisions. Lossing notes that experienced pilots were few and that the entire flotilla with eight thousand men seemed to have been sent out into the black night with virtually no guidance.

At first, the winds were light and the lake was calm. The men toiled at their heavy oars and made good time. But about midnight, the clouds thickened, and in the utter blackness on the lonely unlit lake, the wind began to rise.

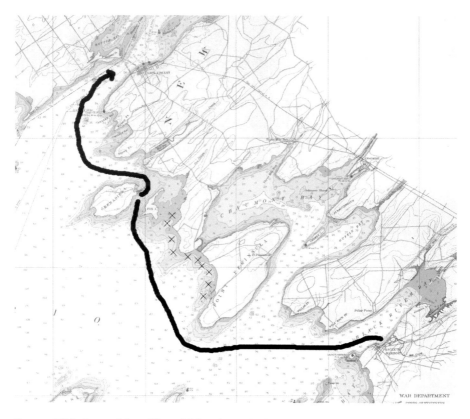

Route of failed expedition. The solid line shows the intended route to Grenadier Island and on to the St. Lawrence, and the Xs represent where the boats, gear and men ended up in part after the cold front storm blew in. *Courtesy of U.S. Corps of Engineers, War Department, Coast Chart no. 21 1937.*

Within moments, it was blowing a full gale with bitter wind, rain and sleet slashing into the fleet. Likely there were flashes of lightning and claps of thunder as the first line of squalls blew in with the cold front. The crews and passengers of the open boats, beset by short, steep, fast-growing seas, were soon fighting for their lives, bailing, scudding before the wind and ultimately in many cases crashing onto the rocky lee shores of Point Peninsula to strew supplies and wreckage for miles around. Fifteen large boats were smashed to fragments that night, and many others were badly damaged. Stores, supplies and ammunition were scattered for miles along the shore and were ruined or lost. More precious supplies went to the bottom of the lake. For thirty-six hours, the northwest gale continued. Not until October 20 did the troops and surviving supplies make their way to Grenadier Island.

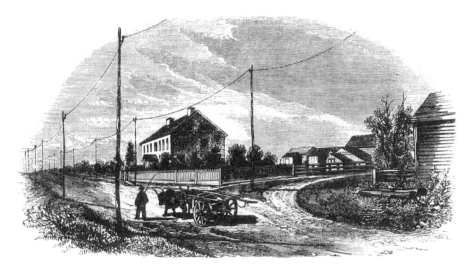

Crysler's Farm around 1859. The battlefield where once American and Canadian militia killed each other was flooded by the St. Lawrence Seaway, a joint Canadian-U.S. project of the 1950s. *Artwork from Lossing's* Pictorial Field Book of the War of 1812.

The weather continued to be bad, and the men remained pinned down on the bleak, low-lying island for several more days. Snow and bitter cold assaulted them as they sheltered under their tents. Up to ten inches of heavy, wet, lake snow blanketed the island, and the men suffered severely from cold and hypothermia. Some of the soldiers began to weaken as pneumonia stalked the crowded island. Wilkinson wrote to the secretary of war on October 24: "The extent of the injury to our craft, clothing, arms, and provisions greatly exceed our apprehensions, and has subjected us to the necessity of furnishing clothing, and of making repairs and equipments to the flotilla generally. In fact, all our hopes have been nearly blasted; but, thanks to the same Providence that placed us in jeopardy, we are surmounting our difficulties, and, God willing, I shall pass Prescott [on the St. Lawrence River] on the night of the 1st or 2d proximo."

At last, the battered army was able to regroup and move on down the St. Lawrence in a fleet of about three hundred surviving boats, harried by Canadian naval forces under Commander William Mulcaster and by militia who fired upon them from the cover of the forested shore. They did pass Prescott, though not until the night of November 6, but they never made it to Montreal. They met the enemy at Cryslers Farm, and in what one Canadian website describes as the battle that saved Canada, the Americans

were defeated by a much smaller but well-led group of defenders. Wilkinson's force was suffering from cold, hunger and disease by the time they reached this final battlefield and engaged the enemy on November 11. The loss of supplies and subsequent delay while bad weather pinned them down on Grenadier Island had cost them dearly. Lossing's account of the battle also mentions that a shortage of ammunition hampered the American forces. He wrote that "victory would doubtless have rested with the Americans had their ammunition held out."

On that dark October night, the lake had sided with the Canadian defenders.

HMS *Ontario*'s Tragic End on Halloween Night

The squall that sank the *Hamilton* and *Scourge* was a blow to Chauncey's squadron, taking out two of his gunboats and 80 trained men in minutes, but an even heavier loss of life had occurred thirty-five years before during another turbulent night on the lake. Unlike the War of 1812, naval action on the lake during the Revolutionary War was limited. The lake was controlled by the British for the entire war. Yet during this conflict, a naval vessel sank with the heaviest loss of life ever to occur in a Lake Ontario shipwreck. One estimate is that 120 people went down with the ship that night.

Her discovery in 2008 by a hobbyist with a homemade ROV is an example of how great adventures and fascinating stories can sometimes be found in one's proverbial backyard. Jim Kennard, a retired engineer and longtime Rochester, New York resident, had hunted for wrecks for several decades. He and many other wreck hunters considered the HMS *Ontario* the "holy grail" of all the Great Lakes shipwrecks. This ship was the subject of a book, *Legend of the Lake: The 22 Gun Brig Sloop Ontario*, by Arthur Britton Smith, first published a few years before her discovery. Rumors had circulated for decades regarding pay chests of silver or gold for the army troops being aboard her. (A story, Kennard points out, with no truth to it. The ship was returning from the fort, so she certainly wouldn't have had any payroll aboard for the troops then.) She also played a role in a historical novel about the lake, and Kennard's video of her was to be used in a documentary.

Underwater wrecks from the eighteenth century are rare anywhere, and some of the most perfectly preserved are those of the Great Lakes and Lake Champlain "ghost fleet." Any eighteenth-century ship above the water today

is either a wreck or a reconstruction, as sailing ship historian Alan Villiers notes (with perhaps the exception of the *Vasa*, which is still being preserved and reconstructed.) The HMS *Ontario* is contemporary with Nelson's *Victory* and is a remnant of the golden age of British fighting sail, a time when the Royal Navy's "walls of oak" were perhaps the greatest in the world. Thanks to British naval records, the *Ontario* is probably the best-documented wreck on Lake Ontario. Her lines and construction details are on record in Admiralty archives. She also, at this point, is the oldest Great Lakes wreck yet found. She is the most intact and original British warship of her era anywhere in the world.

The *Ontario* was a twenty-two-gun sloop of war, eighty feet on deck and of about 225 tons displacement. The term "sloop of war" refers to her size and armament, not to her sail plan. "Sloop of war" was a general term that applied to any vessel of the time with a single gun deck and at least twenty guns. Her sail plan was that of a snow; that is, she had two masts each with three yards and a fore and main. Her hull was mostly of oak cut from nearby forests and adzed for timbers or sawed out in saw pits for planking. Most of the gear, guns, ammunition and other naval stores had to come to Carleton Island from England by way of the St. Lawrence.

The *Ontario* was built at the naval shipyard on Carleton Island near the entrance of the St. Lawrence during the winter and spring of 1780. This was then the major British navy yard on the lake, administered in part by Rènc La Forcc in thc 1780s (see the next chapter for more on him). Several warships were built here, and the island was also an important staging area where supplies for the western campaign were kept and then transported up lake by the HMS *Ontario* and other ships. The island was also a refuge to a number of important and embittered Loyalists who used it as a base to make raids against Mohawk Valley farms and towns.

Although built as a warship to maintain control of Lake Ontario and the northern frontier, the *Ontario* never saw battle in her short life and mostly worked as a transport. All big troop, heavy artillery and supply movements had to be by water in this time when overland transport routes were nonexistent. The *Ontario* made numerous trips up and down the lake between Fort Niagara, Oswego and Kingston. At the time of her sinking, she was carrying men to Oswego for a raid on the Mohawk Valley, the breadbasket of the region. Its crops were vital to the well-being of Washington's northern armies. She was also carrying camp followers and prisoners of war.

She went down in an October northeaster. That year, October was particularly turbulent. The Great Hurricane of 1780 that swept through the

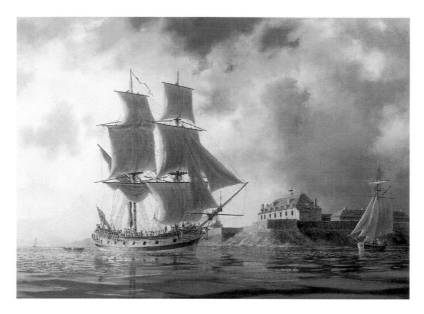

HMS *Ontario* at Niagara shortly before her last fateful voyage. *Painting by Peter Rindlisbacher.*

Caribbean a couple weeks before the *Ontario* went down killed an estimated twenty-two thousand people and sank a number of British and French naval vessels. There is some evidence to suggest the Halloween gale on the lake was caused by or could have been enhanced by the remains of another later hurricane that hit Barbados. No fewer than three bad hurricanes are recorded for that month. Though their exact tracks remain uncertain, the timing and the wind direction are certainly suggestive. Lake Ontario has been hit many times since then by the remnants of hurricanes, and winds of sixty-plus miles per hour have been recorded during those storms.

Whatever their origin on the evening of the sinking, the powerful northeast winds rose rapidly and swept down much of the length of the lake to assault the ship. Within an hour or two, formidable seas had built. When first hit in the darkness by the storm, the ship, which had been proceeding east under full sail, presumably fell off to run with the wind. Or tried to. At some point, the ship was overwhelmed; perhaps she broached to, perhaps she was caught aback or perhaps she was knocked down on her side by the initial blast. Possibly some of the guns on the gun deck broke their lashings and slid to leeward in a heavy roll. Some or all of her canvas blew out or carried away, for a few days later, searchers found large portions of a couple of her sails

afloat on the lake. Whatever happened that fateful Halloween night, the end was probably quick for the men, women and children packed below decks. The ship probably went down very quickly, for little debris came ashore or was found adrift.

The ROV that photographed her in 2008 found the hatch covers missing, presumably blown off by compressed air as she filled. She lies on the bottom at an angle with her masts still in place. The hull shows little damage; even some of the glass in her quarter gallery windows is intact, suggesting that she settled slowly. One gun was photographed lying upset across the ship's tiller.

The day after the wreck, several ship's boats, hatchway gratings, a binnacle, hats, blankets and other gear drifted ashore in the area known today as Golden Hill State Park, located thirty miles east of Fort Niagara in New York State. An extensive search of land and water was carried out by the British a few days later, but the only things found adrift on the lake were some of the ship's sails. In late July 1781, six bodies from the vessel were recovered approximately twelve miles east of the Niagara River near Wilson, New York.

The British did not want their enemies to know of her loss and the subsequent weakening of their naval defenses on the lake, so they did their best to keep word from getting out to the Americans. This probably contributed to the general air of mystery that shrouds the lake's most deadly shipwreck that took place one fatal Halloween night.

RÈNE HYPOLITE PEPIN LA FORCE

Master Mariner, Naval Commander
and Canadian Patriot

Rène La Force was a real version of the fictional sea captains of literature like Horatio Hornblower, recently brought to life on the TV screen, or Captain Jack Aubrey, hero of a series of sea novels by Patrick O'Brian. La Force was a successful and highly effective merchant trader and commander of Canada's first navy. He was also a bush fighter and diplomat on behalf of the various Indian allies of the French during the Seven Years' War and served his native land under both French and British governments. Possibly his actions during the defense of Quebec City in 1775 against the Americans shifted the course of the Revolutionary War to preserve the nation we know as Canada today. C.H.J. Snider calls him an admiral of the lake in two wars for two sovereigns.

Undoubtedly, some La Force references in history's archives refer to more than one man, as Rène had three older brothers who were probably as energetic and effective in battle and civic affairs as he was. What follows is largely from Snider's account of his life in the book *Tarry Breeks and Velvet Garters* and from unpublished work by Robert Townsend. I have also drawn on Paul Truax's family history posted online. There are moments in history where Rène's role is uncertain, but there's no doubt whatsoever that he was a tough, adaptable, quick-thinking survivor avnd an extremely capable mariner who sailed both salt water and the uncharted waters of the eighteenth-century lake in peace and wartime for decades without ever losing a ship to natural causes.

The La Force family came to Canada early in that country's history. Rène's great-grandfather arrived as a young settler in the 1630s. Though

Rène Hypolite Pepin La Force

Rène was born in 1728 in Quebec in a St. Lawrence River village, he grew up by the shore of Lake Ontario at Fort Niagara and came to know the lake as few others did. His full name was Rène Hypolite Pepin dit La Force. In Quebec, "dit" (literally "said") names were used to distinguish French families who shared the same name (Pepin, in this case). "La Force" was attached to an ancestor of Rène's, and Snider translates it as meaning "high flier" or "pusher," which would seem appropriate. Another source translates it as "strong." Rene and his three brothers seem to have been forceful men. They were surely survivors.

Growing up on the frontier in close association with a number of friendly Indians, the boys were quick to adopt the woodcraft and fighting skills of the Huron and Iroquois. Rène spoke French, English and five different Indian dialects, and he and his brothers served as translators between the tribes and the French and English. History records that his father was an educated man who, among other jobs, served as a royal surveyor and as an officer in the militia. Snider and others describe La Force in terms that lead one to assume he was definitely a member of the middle class with a more-than-average level of education.

Rène also took to water like the proverbial duck and soon was serving as a sailor and apprentice aboard the several trading vessels that the French then had sailing on the lake. His marriage record in 1757 listed his occupation as that of trader. After the Seven Years' War, he sailed on salt water carrying cargo between Quebec and the West Indies.

He did not live in an easy time. There was no love lost between the Iroquois and Huron, and young Rène surely heard sagas and stories from his Indian friends about the bloody times of the Beaver Wars fought in the last century as the tribes jockeyed for control of the fur trade on and around Lake Ontario. In the run-up to the Seven Years' War, the French and English both tried to play the Indians off against their enemies, while the tribes tried to do the same to control the frontier lands of the Ohio Valley. In 1754, the western region flared up in an incident that involved a young army officer named George Washington and a Frenchman named de Jumonville who, some say, Washington assassinated. The name La Force appears in correspondence between Washington and the governor of Virginia after Washington took a translator by that name prisoner. Washington wrote, "La Force would, if released, I really think do more disservice than fifty other men as he is a person whose active spirit leads him into all [war] parties…He is a bold enterprising man and a person of great subtlety and cunning. Add to this a perfect use of the English tongue and great influence with the Indians."

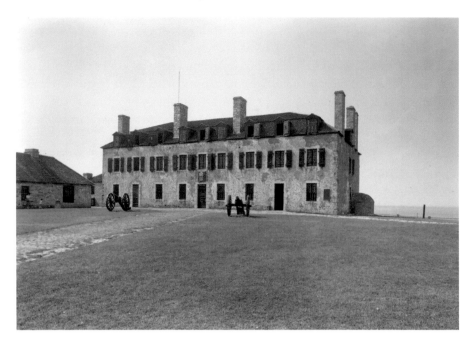

The French Castle, a fortification and trading post at Fort Niagara built in 1727, was familiar to young Rène La Force. It is one of the oldest buildings in the Great Lakes region. *Courtesy of the Library of Congress.*

This La Force was put in prison in Williamsburg, Virginia, and after chipping through a stone wall, he escaped. He was caught and, says one account, "loaded with a double weight of irons and chained to the floor of his dungeon." La Force was not released until March 1759, so obviously he was not involved in any naval action during that time, leading family historian Paul Truax to the conclusion that this was a brother of Rène, the Lake Ontario mariner. This La Force may well have been Rène's oldest brother, Michael.

Rène seems to have been no less enterprising, however, and he had caught the eye of Canadian governor Vaudreuil as the clouds of war darkened the horizon. Rène La Force was put in charge of the lake's naval forces and was given command of the schooner *La Marquise de Vaudreuil*, launched in the spring of 1756. She was ninety feet on deck and carried fourteen eight- and six-pound guns, plus eight small swivels. She was the most powerful warship then on the lake and, says Snider, was quite possibly the largest schooner-rigged vessel yet built anywhere. In the early 1700s, the schooner rig was considered suitable only for small vessels in North America. She had a crew of eighty sailors and marines.

Rène Hypolite Pepin La Force

The First Freshwater Battle in America

Just two months after her launch, the *Vaudreuil* and her three consorts exchanged shots with three British naval vessels in what Snider calls the first freshwater battle in North America. It happened on June 27, and Snider says that the forces didn't yet know of the official war declaration. (France didn't officially declare war on Britain until June 9.) It was a bloodless skirmish with no casualties recorded, but shots were fired, and the smaller, out-gunned British ships fled.

Things were considerably more lethal at Oswego a couple months later when La Force was ordered to blockade the port as Montcalm advanced on it with a large force of three thousand troops, including several hundred Indians. Oswego was the only English outpost on the lake, and its destruction was top priority for the French to protect their vital supply lines. La Force's ships helped move the men during the night, even as his flagship kept the British ships bottled up in port.

Montcalm laid a well-planned siege of the three small forts. The eastern fort soon fell, and once he had moved his heavy guns in position and opened fire, the stone and clay walls of Fort Pepperrell on the river's west side quickly crumbled. After the British commander was killed, the next in command figured the odds were hopeless. He had a large number of noncombatants on hand, including artisans, ship carpenters, laborers and, writes Snider, 140 women and children. He decided to surrender. Then things got really ugly. The British had accumulated a huge stockpile of supplies at Oswego, including lots of rum. The Indians quickly broke open the rum kegs and, says Snider, "went insane." They began butchering, in some cases literally, as history records that one poor officer lying wounded in a tent was cut to pieces. A contemporary account estimated that 100 people "fell victim after the surrender."

The lake then became a "French Pond" for over a year until the fall of poorly prepared and lightly manned Fort Frontenac in August 1758. During this time, La Force's ships were used to ferry goods back and forth between the western trading posts and Frontenac. It was presumably a relatively routine and dull task, with only the lake to deal with. Some years ago, Robert Townsend wrote an interesting account of La Force in action early in the war on transport duty.

On this trip, La Force had to carry ten companies of the regiments of Béarn and Guienne to Fort Niagara. Five hundred men and their equipment were crammed into four relatively small vessels. Townsend figures about half

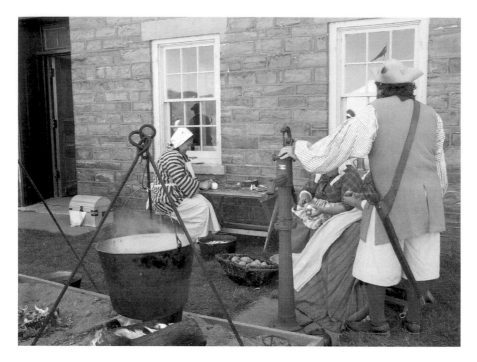

There were many noncombatants present at Oswego when the French assaulted the forts there, as depicted in this reenactment scene from the era. *Author's collection.*

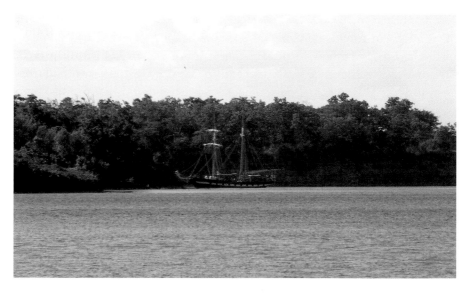

The anchorage behind Main Duck Island with Canadian brigantine *St. Lawrence*. *Author's collection.*

the soldiers had to stay on deck the entire time. The flotilla stood up the north channel from Cataraqui (Kingston) toward the Bay of Quinte on a fine June day. By late afternoon, they had reached Point Traverse, where the False Ducks and Timber Island bar the upper gap passage to the open lake. All afternoon, all evening and through the night, the ships slogged along against the southwest wind and made little headway. By the next morning, when the wind freshened, La Force was much chagrined at the lack of weatherliness of his new craft. He signaled his small fleet to fall off and head for the Isles de Couis (Main Duck and Yorkshire Islands). Here, like many a yachtsman has since, he found calm water and a good short-term anchorage in their lee. He then sent all his cramped and seasick passengers ashore on the two islands for rest and refreshment.

Townsend wrote, "Their hunters killed wild pigeon and some small birds, and they found cabbages and wild garlic, good to eat, a pleasant change from their enforced rations of hard tack, peas and salt pork. They made a June picnic of it. After two days of such relaxation, the wind coming fair at last, they were all crowded aboard again and made a slow, tossing voyage to Niagara."

While the French had full control of the lake, Rène took a short leave. He journeyed downriver to Quebec to marry Madeline Corbin, daughter of a shipbuilding family. With the south shore of the lake secure, the French were able to send a number of raids across to Oswego and then east to the Mohawk Valley settlements. History records the presence of a La Force at the fall of Fort William Henry in August, when a number of prisoners were killed by the Indians after, some accounts say, they were incited by the interpreters. Bougainville's *Journal* refers to an Indian chief named La Force with seventy Ottawas as being on hand. The name La Force also comes up in accounts of the German Flats "massacre" in November. This may or may not have been Rène. In August, one would expect Rène La Force to have been on his ship, sailing supplies and trade goods back and forth on Lake Ontario while the Fort William Henry incident was taking place. The La Force with the Ottawa warriors could well have been one of his brothers. Family historian and descendant Paul Truax suspects that his brother Francoise was present. In November, however, Rène's naval squadron would have gone into winter quarters, and it's possible that he was the man referenced by a contemporary account of the raid on German Flats, also in the Mohawk Valley, that recorded, "Eight Missagas from Ft Frontenac arrived led by La Force the interpreter." Fort Frontenac at Kingston guarded the naval yard that was La Force's base of operations, and it's not a big stretch to see this

enterprising and energetic defender of the homeland using his skills ashore as his brothers were doing, though Truax believes his brother Pierre was the La Force involved.

The raid was typical of French hit-and-run guerrilla tactics. They were greatly outnumbered by the British and adopted the methods of wilderness warfare used by their Indian allies. Often, the small war parties were led by third- and fourth-generation French Canadians like La Force, who were familiar with the country and with the customs and languages of the Indians. In this raid, about 40 settlers were killed and about 150 men, women and children were taken prisoner and marched back to Montreal. While such raids didn't have the grand theater of a battlefield with clear lines of troops facing off, they were very effective psychologically. Snider thinks Rène was there. He writes that he "had English blood on his hands."

On August 25, 1758, a force of about three thousand men under John Bradstreet crossed the lake undetected and landed on shore about a mile from Fort Frontenac. Bradstreet got his artillery ashore and set up and, the next morning, began pounding the old stone walls. The fort was not well defended. The French had only about one hundred troops on hand, along with some militiamen and Indians. After two days, the fort surrendered. Snider says La Force gave the fort commandant his word that he'd fight to the last gun. When a signal for parley was raised, says Snider, La Force hurried all the hands he could muster aboard his ships. There was no wind, so the men kedged out of the anchorage and tried to tow the three largest vessels into open water using ships' boats, only to be raked by British fire. Snider says La Force himself bent to the oars, but there were too few men for the task. The ships were lost to the British. But La Force and a small company of men escaped in a small vessel, a "shallop rigged for rowing and sail." With seven sweeps to the side she crept away "unnoticed down the St Lawrence." La Force took about forty men and eight Indians, three of them burned almost to death by a bombshell lobbed over the fort walls by the British. The French tide had turned.

A year later, Fort Niagara fell. La Force was present, in command of the *Iroquoise*, a corvette-class ship of about 160 tons built by the French to replace the lost navy of Fort Frontenac's destruction. She was rigged as a topsail schooner and carried ten twelve-pound guns. He did his best to harass the large forces that moved by land into position to lay siege to the fort, but there was little he could do with his light armament and small complement of fighting men. A few pages of a journal he kept during the siege have survived and been translated. In it he notes, "At noon I sent my shallop

ashore to look for trucks for gun carriages, seeing that all mine were broken, and for pump-nails, our vessel making water since yesterday. The gun [with the trucks broken] has jarred her, and opened a butt in the waist on the starboard side. I have been obliged to put two pieces [of ordnance] into the hold, through faults in the guns and their carriages." Pump nails made with serrated edges had greater holding power than regular spikes, much like today's ring nails used in boat building.

Fort Niagara held out for almost three weeks before it fell. The way for the British to proceed to Montreal and Quebec was now clear. Only La Force's two ships and a small French fort stood in opposition. The only haven left for the *Iroquoise* was the St. Lawrence, where her consort *L'Outaouaise* lay repairing. La Force kept up guerrilla warfare for thirteen months, fighting on land and lake and living off the wilderness until the Battle of the Thousand Islands on August 17–24, 1760. This last stand of the French as they defended the way to Montreal was one of the bloodiest and most intense freshwater naval actions of the entire war. When the smoke cleared, La Force was one of a handful of survivors.

In August, General Jeffrey Amherst set out from Oswego with 10,000 men bound down the river to take Montreal. His was one of three armies, the other two moving upriver from Quebec and along the Richelieu, respectively. As Amherst's force approached the small French Fort Levis, located near present-day Ogdensburg and Prescott, the two British warships sighted a small French row galley and went off in pursuit. They promptly got lost in a maze of islands and were out of action for several days before they got back to the main channel. Amherst's forces, meanwhile, proceeded downriver and captured the *Iroquoise*'s sister ship, the *L'Outaouaise*, after a lively action. They repaired the ship and manned her against the French. La Force's vessel was lying aground under the guns of Fort Levis, and when the assault began, he and his crew were ordered to the fort to assist in its defense. At dawn on August 20, the three British warships with fifty guns combined began firing on the fort's wooden walls. One British ship claimed to have fired 892 shots. Serving just five guns, the defenders hit the captured *L'Outaouaise* forty-eight times. Eventually, they sank her and the *Onondaga* and pounded the *Mohawk* out of action. The British continued firing from guns set up on surrounding islands and began using heated cannonballs to start fires within the fort. Still the defenders held on. For four days, they returned fire until they ran out of ammunition and surrendered. About 275 of the 300 defenders were killed or wounded. The British could hardly believe that the small force had been able to offer

General Amherst led the assault on Montreal. The troops in their bateaux running the rapids of the St. Lawrence are shown in the background. *Courtesy of the Library of Congress.*

such a spirited resistance, according to one military historian. Scarcely a week later, Montreal fell. La Force was taken prisoner.

At the end of the war, the British demanded that all French military men, including those who had been born in Canada, return to France. The victors were worried about the stability of their newly conquered countryside, and among other concerns, they definitely did not want any Frenchmen fluent in Indian dialects stirring up the resident tribes or raising up a rebel army of unhappy Catholics. They provided three ships to transport the exiles. One of them was the ill-fated *Augusta* (also spelled *Auguste* before the British took her as a prize from the French). She was wrecked on the coast of Cape Breton, and of her crew of 15 and 106 passengers, only 7 survived. One of them was a man named La Force.

THE *AUGUSTA*'S AGONY

I have included an account of this famous wreck far from the shores of Lake Ontario because I agree with C.H.J. Snider's conclusion that Rène was aboard, though others have pointed out that he may not have been. We don't know for certain. As former commander of the French fleet, he was the highest-profile military man of the family, and I think he was the most likely one to have been sent out of the country. Most of the male passengers were ex-military, and a number were officers who, like Rène, were "figures of influence and authority," according to one account. Some of the exiles still had some money after the long war and took their stashes of silver and gold coins with them. This, along with a vivid eyewitness description of the ship's last days, has made the wreck famous and much sought after.

The ship sailed late from Quebec on October 15, 1761. The *Augusta* was small, only about 240 tons displacement and perhaps seventy feet on deck. She was a former French merchantman taken as a prize by the British navy. Her crew, when she was taken, had numbered thirty-nine, so she may have sailed a bit short-handed that October with only fifteen sailors aboard. It was late to be facing the North Atlantic, as Rène La Force must have been keenly aware. Unlike some of the former officers aboard, he did not take his family with him. Perhaps he thought he would establish himself in France and then send for Madeleine when she could make the crossing in better weather. One of his fellow passengers was fifty-year-old Saint Luc de la Corne, a trader of considerable wealth and another old Indian fighter whom La Force may well

have known. Luc de la Corne kept a diary while aboard the ship and so has left us a vivid and chilling account of its last days.

It took the *Augusta* several weeks to fight her way out of the St. Lawrence against the wind and tide. Luc de la Corne wrote a few days before the end, "4 to 6 November a violent NE wind brought a severe storm. All our trunks and boxes broke loose, most of our cabins were damaged and several people were injured by the luggage. We also lost provisions and were not able to cook. The Captain assured us afterward that in eighteen years of sailing he had never seen such a storm." The next day, he noted, a fire broke out in the galley, and "this time the ship was much more damaged by it than before."

On November 11, he recorded that another northeast gale blew them down onto Cape Breton. "In the night we passed close to a cliff and only a wind shift saved us." The battered, short-handed ship blew down the coast and was trapped in a big bight, not unlike Lake Ontario's dreaded Mexico Bay, from which she could not escape. She couldn't beat out to sea against the force of a full-blown Atlantic gale. During the storm, several sailors were injured, and some of the passengers were standing watches to help work the ship. On November 14, they sighted land, but having only charts of Europe on board, they had no idea of their location.

For three days the gale blew. La Corne wrote that the short-handed crew was so exhausted they took to their hammocks. The mate tried to rouse them and threatened to flog them, but his efforts were futile. The men, worn out from exhaustion, cold and lack of food, said they preferred to die in their hammocks. The mizzen was broken and the sails in shreds; it was impossible to work the ship.

The next day, she drove onto the sands of Aspy Bay. She went aground about forty yards from shore and broached to immediately. Many people below decks were drowned before they could get out on deck. Those who did manage to escape clung to the wreck for a couple of hours before one of the boats worked loose. Some of the survivors managed to get ashore with it. In all, only seven made it. After the wreck, the survivors did their best to bury the dead who washed ashore. Several of the castaways, including La Force and Luc de la Corne, were experienced in wilderness travel. La Corne's diary records that they believed they were on Cape Breton, and with that in mind, they struck out for what they thought was civilization. After nine days, they came to the village of Ingonish but found only empty houses and two corpses. They left two sick men behind and continued on.

On December 3, they reached St. Ann's Bay. There they found a derelict boat and spent two days patching it up. Then another winter storm blew in,

trapping them on shore. Even these iron men were beginning to lose hope when two Indians found them. With the help of the Indians and two canoes, they made it to the tiny settlement of St. Peters. Here, La Corne wrote to the governor at Louisberg telling of the wreck. La Force and two other men took the letter to that town. La Corne, however, decided to head back home. He'd had enough of this exile business. Maybe he figured Providence didn't intend for him to go to France. Maybe La Force, who once owned a ship by that name, figured the same.

La Corne made an incredible trek back to Montreal on snowshoes to return to his family. He truly was an iron man. He made it back to Quebec by February 22 and was in Montreal two days later. It was an astounding journey of 1,700 miles in three and a half months in the cruelest winter conditions imaginable short of the high arctic. He became moderately famous even among the winter-hardy Quebecois for this feat.

History doesn't tell us what next became of Rène. Maybe he waited until spring and then slipped home quietly to his own waiting wife, Madeleine, and children. Perhaps the new British governor, General Murray, was inclined to give these indomitable Canadian survivors a break, especially after hearing of La Corne's feat. Snider writes that La Force kept a low profile as he gradually reentered civil society and the trading and shipbuilding business of his wife's family.

The *Augusta* broke up quickly, but in 1977, the sands of time in Aspy Bay shifted, revealing a few bits and pieces of metal. Soon, treasure hunters found old cannons and ballast, bits of ship hardware, silverware engraved with family crests, silver buckles, a watch case, sterling silver sugar tongs, a nutcracker and gold coins, many showing little circulation wear, suggesting they had long been hoarded. They were all scattered by the sea and buried by the sand.

For the next twelve years, Snider tells us the onetime admiral of the French navy on Lake Ontario led an "ordinary" life. Snider says La Force went to work at his in-laws' shipyard and, after a few years, began sailing to Dominica and the West Indies in command of a ship named *Jazon*. There is an interesting reference in the papers of William Johnson dated 1765 that states, "Jingunswee's brother named La Force had been at the Three Rivers near Oswego last summer purchasing ginseng from the Six Nations." (Jingunswee is thought to be Rène's brother Francois. Perhaps that veteran fighter had decided to go permanently native.) By 1774, Snider records that Rène had acquired part ownership of the schooner aptly named the *Providence*. But then the clouds of war gathered once more.

BACK ON DUTY

When the Revolutionary War began, Rène was among the relatively few Frenchmen who opted for active duty in defending Canada from the Americans. The British were not popular in Quebec, despite the relatively lenient treatment they had given the conquered Catholics, and many French Canadians remained neutral during the war. But Rène decided to throw his lot in with the British, as he once again volunteered to defend his homeland. He was commissioned a captain of artillery in the Quebec militia. He soon found himself in the middle of a firefight in the battle for Quebec.

French Canadians fought on both sides of this battle. It began with the boom of cannon as the Continental army forces opened fire on the stone walls of the old city on December 10, 1775. The American commander, Richard Montgomery, believed the only way to take heavily fortified Quebec was to climb its walls under cover at night in a snowstorm. He planned two attacks, one led by himself and the other by Benedict Arnold. They launched their assault on the night of December 30 in a blinding blizzard. After breaking through the city's outer defenses, Montgomery led his men down a narrow street toward a blockhouse held by a handful of militia. Snider says La Force was among them. Battlefield events are often muddled in memory and accounts differ, but one early description of the battle says the blockhouse had been deserted and that one or two defenders had returned to it. The defenders held their fire until the Americans were about forty paces away and then opened up point blank with musket fire and a single charge of grapeshot from the cannon. Montgomery was hit in the head and both thighs by grapeshot and died instantly. The surviving attackers fled. Arnold failed to take the city, and Quebec held. That single well-aimed cannon shot may have assured the future existence of Canada.

La Force and his partner leased their schooner *Providence* to the British for defense of inland waters, and La Force took command. Before long, his talents were obvious enough that he was again a commodore. In 1776, Snider wrote, he was appointed "Commandant des Batiments sur le Lac Ontario—twice appointed commander of the fleet the first and only Canadian-born sailor to be so honoured." He remained in this position until 1786. During the winter, when navigation on the lake shut down, he continued to make his trips to the West Indies aboard his own schooner, the *Rose*. After taking retirement as commodore, he remained active and was placed in charge of shipbuilding and

Rène Hypolite Pepin La Force

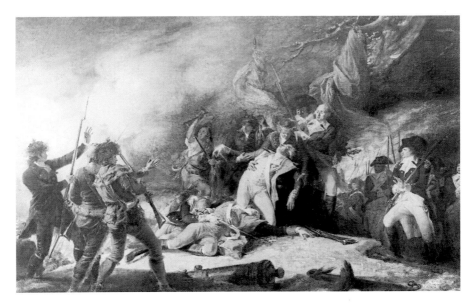

General Richard Montgomery's death from point-blank cannon fire. *Courtesy of the Library of Congress.*

navy yard construction at Kingston and Carleton Island, where perhaps he watched the doomed HMS *Ontario* sail forth on her first voyage.

After the Revolutionary War ended, Snider writes of an attempt by La Force to acquire seven hundred acres of prime Toronto Harbor waterfront. He and a comrade in arms petitioned for land grants then being given to veterans for war service. He was upstaged by another better-connected land speculator whose demands, Snider says, were so outrageous that the governor refused all the requests. The grants were given to those whom the governor saw as solid, trustworthy English-speaking Loyalist settlers instead. I find this incident of interest. I believe it reflects La Force's lifelong affinity for the sweet-water sea on which he first ventured forth under sail. He was given land in Quebec, and there with wife and family he lived out the rest of his days and died at the age of seventy-four. Townsend writes that he was active in community life up to the end and concludes, "The parish register of Notre Dame Quebec records his death Feb. 5th 1802 at the age of 74. It modestly records that he was a Justice of the Peace, Lieutenant Colonel of the first Battalion of Canada Militia, formerly Captain of the King's vessels, and a church warden of this Parish."

Rène La Force was born on December 5, 1728, a Canadian under the French flag. He died on February 5, 1802, a Canadian under the British flag.

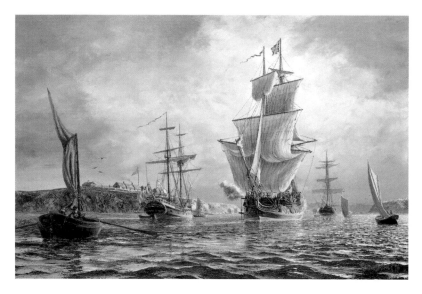

HMS *Ontario* was built at the Carleton Island Navy Yard during the time La Force was stationed there. *Painting by Peter Rindlisbacher.*

One of his great-grandchildren was Monseigneur Langevin, first bishop of Rimouski; another, Sir Hector Langevin, was a father of the Confederation and a minister of the Crown. "He should be remembered," concludes Townsend, to which I can only add "Amen."

Captain Van Cleve

Businessman, Artist, Author and Mariner

Many smart (and wealthy) people believe that innovation and efficiency are key to mankind's future well-being and possibly even to our very survival on an overstressed planet. History shows the benefits of adopting new technology and changing with the times. Captain James Van Cleve was an innovator of the nineteenth century. But he was also a man with a keen appreciation for history and for the natural environment in which he lived and worked during a long and successful career.

He was born near salt water in New Jersey in 1810 and arrived with his family in 1820 in upstate New York, where they settled near the west end of Lake Ontario. He grew up in Lewiston and many years later retired there. His life spanned the most interesting and lively period of maritime activity on the lake.

After a short and unsatisfactory beginning as a store clerk, a career that he noted in the beginning of his *Reminiscences* was not very lucrative, he found himself "drifting upon a financial lee shore" and took a position as a clerk aboard the steamer *Ontario* in 1826. This was the start of his "long connection with the commerce of Lake Ontario." Van Cleve commanded a series of steamers, helped found a successful passenger line (the Ontario and St. Lawrence Steamboat Company) and was its general manager for a number of years. He was never shipwrecked, but his boat was hijacked by pirates once, and the "farce," as he termed it, turned deadly and cost him his job. But he bounced back and went on to command other ships. Captain Van Cleve lived in an interesting time. It was a time when three great

technological innovations had a worldwide impact on marine transport. Some of the earliest development of those innovations occurred on Lake Ontario, and Van Cleve played a direct role in the commercialization of one of them.

He also wrote of those interesting times in a combination memoir/ compilation of maritime facts/artwork. He made several copies of his *Reminiscences of the Early Period of Steamboats and Sailing Vessels on Lake Ontario, with a History of the Introduction of the Propeller on the Lakes* (one source says there are seven in existence) and presented one to Oswego and another to the Buffalo Historical Society for preservation and public access. Van Cleve was a very capable watercolor artist, and since he was also an old captain, it's a pretty sure bet that the images of early steamers that he knew personally and, in some cases, commanded are accurately rendered. His work is often cited in Great Lakes histories. He was a keen observer and had a great interest in establishing and preserving the facts to his best ability. It is interesting how little he reveals of himself in his monograph. He tells us his father's name and a sentence or two about him but nothing about his mother, wife, children or other personal details. Like so much of nineteenth-century history, it's very much a man's world, filled with male achievements and business doings.

One section of *Reminiscences* deals with early sailing vessels. In it, Van Cleve wrote that around 1806 or 1807, the first centerboard was put in a schooner on Lake Ontario and that it was modeled after a skiff brought from Niagara. He notes this event for good reason. The drop keel or centerboard is a movable keel that allows shoal-draft sailing ships to sail upwind. If the ship enters shallow water, the keel is raised by pivoting or lifting it up into a watertight housing bolted onto the inside of the boat. In a time when waterways were vital to the transport of goods and people, trade was the economic lifeblood of numerous small coastal cities and towns. But on the lake (and elsewhere), many eighteenth- and early nineteenth-century ports were located on shallow harbors that had entrance channels blocked by shifting gravel bars. The centerboard opened up vast new territories for trade, and huge opportunities for jobs and profits in shipping and related industries quickly followed.

Shoal-draft schooners with centerboards carried grain, lumber, coal and other goods for over a century on all the Great Lakes and on saltwater coasts around the world. Well into the twentieth century on Lake Ontario, schooners still serviced small ports like Napanee and Port Hope that needed coal to power their mills and factories and heat their homes.

Captain Van Cleve

Most maritime histories say that a British naval officer named John Schank invented the drop keel sometime in the 1770s. He may have seen it in use in some far-off foreign port like China. If he didn't invent it, it's certain that he did introduce it to the navy. By the late 1700s, warships of considerable size were being given two or even three sliding keels. Schank is said to have introduced the retractable keel to Lake Champlain, where he was stationed during the Revolutionary War. Sliding keels were built into small boats so they could sail upwind and also be sailed onto the beach during amphibious landings. From there, the centerboard made its way to Lake Ontario as soon as the Americans and British negotiated the new republic's northern border after the Revolutionary War. This allowed settlement trade and boat building on the lake's south shore. By the 1830s, centerboards were in wide use on the Great Lakes and on salt water.

Captain Van Cleve makes no mention of sailing aboard schooners in his book. He seems to have been a steamboat man. Much early experimentation in steam navigation took place on Lake Ontario, and Van Cleve was associated with the new industry almost from the start. The first commercially successful steamboat in North America was launched on the Hudson River in 1807. Just a few months after the War of 1812 ended in 1815, a group of investors began building a steamer that was launched at Sackets Harbor in 1816. She was the first paddle-wheeler designed to travel on open water and the first boat to move under steam on the Great Lakes. As the *Oswego Palladium* put it in a story about Van Cleve, "Up to the time of the appearance of the *Ontario* it was an unsettled question whether a steamer could be used on the lakes, or the ocean, for it was contended by many that the waves would disarrange the machinery and leave the boat at the mercy of the waters."

The impact of steam-powered boats on economic development on the lakes and everywhere else in the world was profound. There was good reason for the response of the public as recorded by Van Cleve when the ship reached Rochester on her maiden voyage and was greeted "with expressions of great joy." Suddenly, it was possible to transport goods and people on a schedule. No longer were humans hostage to the winds. Now they had at least some independence from Mother Nature's whims.

The *Ontario* was built of wood. She was 110 feet long and about 240 tons displacement, and Van Cleve's painting of her shows her to be schooner rigged, with a single headsail and a foresail that brailed up. She could do about seven miles an hour under steam. General Jacob Brown, the War of 1812 hero, had an interest in her, says Van Cleve. The *Ontario*'s engine was

The pioneer steamboat *Ontario* (not to be confused with a later steamer of the same name). *From J.R. Robertson's* Land marks of Toronto, *supplied by Walter Lewis, www. MaritimeHistoryOfTheGreatLakes.ca.*

built at Elizabeth, New Jersey, by Daniel Dod, a respected engineer who also powered the *Savannah*, the first steamer to cross the Atlantic.

The *Ontario*'s maiden voyage was not a complete success. She sailed from Sackets to Oswego without incident and then departed for the Genesee River and got there that evening. After leaving Rochester and heading up the lake, wrote Van Cleve, a northeaster blew in and raised a "considerable swell." "Like all steamers previously built for still water the bearings under the out[er] ends of the shafts were considered sufficiently secure by the weight of the shaft without the necessity of bolting the boxes to the boat timbers. The action of the waves soon lifted the shafts from the out end boxes and the wheel coverings were at once torn in pieces utterly demolishing them by contact with the wheels which were considerably damaged." The *Ontario* "put about and returned to Sackets to repair damage and secure the shaft by proper bolting." On this trip, she used her auxiliary sail plan to good advantage.

Van Cleve served aboard the *Ontario* for several years before working his way up to captain. The boat Van Cleve started his career on almost ended hers shortly after her launch, he wrote, when she ran aground in the Oswego River and was stuck for several days before she was extricated from her

perilous position. The year Van Cleve joined her as clerk in 1826, she was feeling her way slowly up the St. Lawrence in the Thousand Islands when she ran aground on a rocky shoal. She was not very much damaged. She was repowered in 1828 "with a view to give her more speed." This, says the old businessman-captain, "incurred great expense and was to no advantage."

Once, a severe storm came up when the *Ontario* was near the west end of the lake. She anchored to ride it out for the night but began to drag toward shore and had to slip her anchor in about four fathoms of water, where, wrote Van Cleve, it probably remains to this day "for the fishes to sharpen their teeth upon."

In the early days of steamboating aboard the *Ontario*, Van Cleve wrote of an incident to which today's frustrated boaters trying to get into a dock with the wind blowing off it can surely relate. Back then, the *Ontario* did not have signal bells, so the captain used commands to the engine room sent via a man or boy posted to pass the commands down to the engineer. "Mr. Ramsey was in that post for several years. The usual commands were Stop her Mr. Ramsey! Back her Mr. Ramsey! Go ahead Mr. Ramsey. At times when the boat did not come readily up to the wharf some wag among the crew would sing out 'give her a stroke sideways Mr. Ramsey!'" The first American steamer on the lake was a commercial success, and Van Cleve says she survived until 1832 and was broken up in Oswego.

Early steam navigation on the lakes saw considerable experimentation as builders and owners sought the most profitable yet safest boats possible. A catamaran hull steamer was built in the hope that it would prove fast enough to be able to navigate the rapids of the St. Lawrence. It wasn't. The two-hundred-ton *Toronto* was double planked with "strong brown paper" between the layers of planking and had no heavy timber frames. This effort to create a light, strong, stiff hull failed. After just five years, she was condemned. In the early 1840s, a small iron-hulled ship, the *Mohawk*, was launched at Kingston. Another larger iron vessel, the *Peerless*, was put together at Niagara from parts shipped over from Scotland. She was launched in 1853 and carried passengers between Lewiston and Toronto. The *Magnet* was another iron ship, launched in 1847. These lake steamers were built early in the evolution of iron hull construction. Not until 1837 did an iron steamer receive an insurance rating from Lloyds, as the material was still considered experimental. A contemporary observer records that it was the boilermaking art that led to the art of iron shipbuilding. The iron hull's strength and great durability, along with the ever-present hazards of fire associated with wooden steamers, made iron appealing, though admittedly

Van Cleve's first command was the steamer *Martha Ogden*. This engraving from Robertson's *Landmarks* is likely taken from the captain's watercolor sketch of her. *Supplied by Walter Lewis, www.MaritimeHistoryOfTheGreatLakes.ca.*

it was an expensive option for steamers. Wooden ships also often suffered severe damage from dry rot in as little as ten years. Sometimes steam engines and machinery outlived the wooden hull and were used to power a second or even a third boat.

In 1830, Van Cleve was promoted to command of the *Martha Ogden*. She was a small steamer of about 150 tons with auxiliary sail and ran between Rochester and Kingston with stops in Oswego and Sackets. On one of her first trips into Kingston, she encountered fog, and Van Cleve, creeping along carefully through the mist, ran her aground on one of the unmarked shoals surrounding that port's somewhat tricky approach, as many a yacht has done since. She wasn't damaged, and the navy yard sent help out to get her off. Afterward, the commandant invited Van Cleve for dinner and gave him a tour of the navy yard. He went aboard the laid-up 110-gun ship of the line *St. Lawrence* and recalled that the commander pointed out a large hemp anchor cable "said to have been taken at Copenhagen by Lord Nelson." Van

Cleve's interest in history was evident as he wrote of the commandant's war stories, which included an expedition up the Penobscot River to destroy the U.S. frigate *John Adams*.

A few years later, Van Cleve found out for himself what it was like to be shot at. It happened while he was in command of the big steamer *United States* during an unfortunate and occasionally bloody period of political turmoil, now largely forgotten, called the Patriot War. In the late 1830s and '40s, unrest and resentment built among the populations of upper and lower Canada. French Canadians felt, with justification, that they were being treated as second-class citizens by a corrupt and ineffective government and began demanding more of a role in its function. In Ontario, where the "old guard" had firm control of things, reformers also began pushing for a more democratic government. Americans like "Pirate Bill" Johnston of the Thousand Islands and groups like the Hunters Lodges of northern New York were happy to support the polarization and stir up trouble. Religious and ethnic overtones and long-standing grudges and resentments eventually escalated from heated rhetoric to violence, and several nasty little skirmishes between armed Patriots and British soldiers and militia ensued. One of these, the Battle of Windmill Point, took place in November 1838.

Van Cleve knew trouble lay ahead when a large group of single men boarded his steamer at Oswego on her last trip of the season. He recalled in his *Reminiscences* that they were unarmed, and I suspect he felt he couldn't refuse them passage merely on suspicion. But then another large all-male group came on board in Sackets. They proceeded down the river until they encountered a schooner. One of the passengers told the captain this was his boat and he wanted very much to get it to Ogdensburg with an important cargo. Could the *United States* take her in tow?

Van Cleve agreed. But when the schooner was alongside, off came her hatches and out came a mob of armed men. The *United States* was then hijacked for the invasion of Canada. After landing the approximately 250 Patriots on shore at Windmill Point, the *United States* was fired upon by the British ship *Experiment*, and a ball passed through the pilothouse and killed the steersman, "taking off half his head." After this "serious part of the farce," the steamer was run aground deliberately by her captain and seized by a U.S. marshal. In the process of getting her out of the government's clutches, Van Cleve wrote, the owners needed a scapegoat, and he was it. He lost his command. The Battle of Windmill Point turned into a rout; eleven Patriots were executed by the British, and another sixty were transported to Australia. "Pirate Bill" Johnston was arrested by the United States, though

The steamer *United States*, an unlucky boat. Launched in 1831, she was taken by the Patriots for the Battle of Windmill Point. Engraving from Van Cleve watercolor. *Supplied by Walter Lewis, www.MaritimeHistoryOfTheGreatLakes.ca.*

he was later acquitted for lack of evidence. After Van Cleve left her, he wrote, the *United States* was involved in a collision that nearly sank her and then ran ashore in 1841. "The excitement and fatigue of getting the boat off the shore brought on a fever from which Captain Whitney died." The unlucky vessel was broken up in 1843.

The following season, several old business associates in Oswego who believed in Van Cleve's abilities asked him to take command of the two-year-old, 450-ton steamer *St. Lawrence* after she had been run aground and damaged considerably under her previous skipper. He stayed with her until 1847, when he took over the brand-new ship *Cataract*.

THE *VANDALIA*, A LAKE ONTARIO FIRST

The screw propeller has been called one of the most important inventions of maritime history. Like many revolutionary inventions, it evolved through time, with dozens of people working on the idea in multiple

locations. One early Lake Ontario pioneer was Horatio Nelson Throop of Pultneyville, later a rival and a business associate of Van Cleve's. Throop built and launched an undecked two-ton boat in 1832 that was powered by a screw propeller of his own design. Eight years later, a chance encounter between an Oswego businessman who asked Van Cleve to meet with him and the Swedish engineer John Ericsson in New York City brought it to the Great Lakes.

People had known about the ability of screw to move water since at least the time of Archimedes, and Robert Fulton made reference to a "spiral oar" in his writings. By 1785, the idea had been patented by a British inventor. He never did anything with it, so its development was left to a half dozen engineers and inventors the likes of Throop and Ericsson. Much of Ericsson's early sales effort was directed toward the military. He promoted the advantages of the submerged screw propeller over the exposed and fragile side-wheel paddles for warships. He is remembered as being the designer of the Civil War ironclad the *Monitor*, often credited with being the first "modern" U.S. warship. However, it was the limitations of canals in both Britain and the United States that gave Ericsson his first big break in the world of commerce.

The compact screw propellers had several big advantages over the side-mounted paddle wheels used by lake steamers. They were mounted aft and under the boat's stern so they were out of the way when entering a narrow canal lock. They also worked better in rough water. When a paddle-wheel steamer rolled, one or the other wheel often came out of the water. In bad storms on the Great Lakes, such steamers floundered around and sometimes even broke their drive shafts because of the uneven strains on their machinery. They then drifted helpless before the wind and ended up wrecked.

The screw propeller was also more efficient than the paddle wheel because the screw blades were always submerged and continuously applying thrust, unlike the paddle wheel's blades, which drove the ship forward only during a small part of their revolution. More efficiency and less fuel consumption made ships cheaper to operate. A paddle-wheeler powered by cordwood went through a virtual forest of trees each year, resulting in deforestation and soil erosion along the lake. A big steamer would use about a cord of wood an hour, and wood before the Civil War was the main fuel of choice on the lakes. The machinery to drive a screw propeller was also more compact than that of the side-wheelers, so there was more room in the hold for cargo. However, side-wheelers could operate in shallower water and in flat water

were faster, so they hung on for many years in the passenger trade on the lake, where they didn't have to negotiate any locks.

Captain Van Cleve immediately realized that a screw-propelled ship could be built with more beam, so it could carry more cargo through the narrow locks of the Welland Canal. He wrote of his meeting with Ericsson that they talked for about two hours about the commerce of the lakes and the potential of the propeller already in use on the Rideau Canal. Then, recalled Van Cleve, "He [Ericsson] got up from his chair, walked two or three times across the room and then made me the following proposition. Capt Van Cleve, if you will put a vessel in operation with my propeller on the lakes within one year I will assign you one half interest in my patent for all the North American Lakes. I accepted this proposition, the papers were drawn up and I left for Oswego."

Van Cleve wrote, "An arrangement was concluded with Sylvester Doolittle who had a shipyard in Oswego to build a new vessel" designed specifically for the machinery. An Auburn company built the engine, and Van Cleve took a quarter interest in the new ship. They launched her that fall in 1841, just a month before the one-year deadline. She was ninety-one feet on deck and had about a twenty-foot beam to fit the locks and displaced 138 tons. She also had a good-sized mainsail for auxiliary power, as did many open-water steamers of the time. The vessel had two six-foot propellers and shafts and a fifty-horsepower steam plant. She was named *Vandalia* after the then capital of Illinois. (At the time, trade between Chicago and the East Coast via the lakes and Erie Canal was increasing rapidly.) She was sloop rigged and set her sails whenever the wind favored her course to help her along.

The *Vandalia* promptly set off on a demonstration/sea trial run up to the west end of the lake. As part of her trials, she went as far as St. Catherine on the Welland Canal, where she was well received. The local paper reported that "she steers…delightfully, the movement of the screws assisting rather than retarding the action of the rudder." Heading home from her maiden run, she encountered some November weather and gave a good account of herself as a competent sea boat. Her skipper declared that he thought her the safest vessel he had ever sailed in, able to stay off a lee shore in rough weather thanks to her engine and propellers. The next spring, Van Cleve wrote, "The *Vandalia* went thru the Welland to Buffalo where she was examined by all classes with much interest."

She soon had several successful sister propellers in the Oswego to Chicago trade, much to the chagrin of Buffalo's boosters, who had dubbed the *Vandalia* the "Oswego Humbug." At that time, there was a fierce rivalry

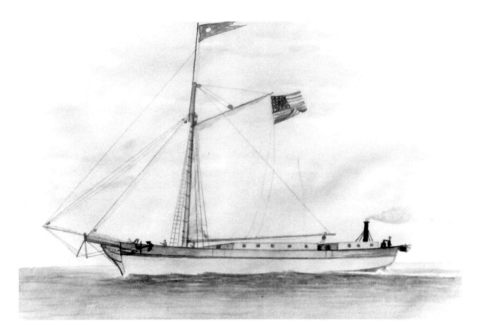

The auxiliary sloop *Vandalia* had the first commercially successful screw propeller. Here she is portrayed in a watercolor sketch by Van Cleve. *Artwork supplied by R. Palmer.*

between the two cities. The Oswego newspaper enthused that the Ericsson propeller would work wonders for the city, adding 50 percent to the value of property in Oswego. Within a few years, four propellers had been built and launched at Oswego, while others were built at Rochester and Sackets and some existing steamers were also being converted to propellers. We will never know how many lives were saved by the early introduction of the propeller to Lake Ontario shipping. But it is a certainty that the technology was faster, safer and more economical for hauling freight between the lakes.

Ontario and St. Lawrence Steamboat Company

Van Cleve commanded several other steamers after the *United States* fiasco. One of his last commands was the *Bay State*, a big steamer built in Clayton. By this time, he was increasingly ashore tending to business affairs as secretary-treasurer and general manager of the Ontario and St. Lawrence Steamboat Company. In 1852, the line ran between Lewiston and

The Genesee River near Rochester at the time when it was a stopover for Van Cleve's Ontario and St. Lawrence Steam Boat line. *Supplied by Walter Lewis, www. MaritimeHistoryOfTheGreatLakes.ca.*

Montreal and offered two options for travel. The U.S. Mail Line of "large and commodious" steamers and three beautiful river steamers "expressly adapted for navigation of the rapids" ran daily and connected with railroad terminals at Oswego and Ogdensburg and points downstream. A second route, the American Express Line, ran from Niagara Falls to Montreal with one stop in Toronto.

Van Cleve wrote and illustrated a guide for travelers aboard the boats. It was part promotional piece, part guide with schedules and pricing and included practical suggestions for handling baggage and travel. It also described points of interest. Van Cleve's writings about the beauty of the scenery and the abundance of historical incidents of the lake shoreline communities reveal his own interests, as later enlarged upon in his *Reminiscences*. He also assures passengers, "As proof of the care and skill with which the American steamers have always been conducted on these waters, it can be said of them what can not perhaps be said of any other line of steamers or railroad in the world of equal extent, *that there has never occurred an accident by which loss of life was occasioned* [Van Cleve's italics]."

He had good reason for such reassurances. Especially in the earlier days of steam navigation, when the boats were built of wood and fueled with wood,

The side-wheel steamer *New York*, Van Cleve's last command, shown in this early stereoview before she left the lake. Note the piles of wood on the dock beside her. *Supplied by Walter Lewis, www.MaritimeHistoryOfTheGreatLakes.ca.*

accidents were far from uncommon. Boilers exploded, boats caught on fire and always the lake waited for the unwary and the unprepared. Vigilance both on deck and down in the engine room was essential. Poorly maintained pipes and boilers could fail or blow up with great violence. An inspector's accident report from the 1830s describes finding a heavy cast-iron boiler lying reversed end for end where it had fallen, presumably after being airborne and flipped in the explosion. Van Cleve was well aware of these hazards. He recorded in his *Reminiscences* that the man who built the pioneering steamer *Ontario*'s engine was himself killed in a steam accident. Daniel Dod, according to a government report, was making some experiments on a high-

pressure boiler that was "miserably weak" and the "end was blown out." Dod and several others lost their lives for "want of skill," notwithstanding the assessment that he was "a steady sober ingenious and industrious man."

The Ontario and St. Lawrence Steamboat Company was probably near its peak years of prosperity when it launched the *Ontario* in the spring of 1848. This fine vessel, like several other company ships, was built by the Merrick Shipyard in Clayton. This *Ontario* was designed and commanded by Van Cleve's business associate, H.N. Throop. A contemporary news account said of the new ship, "We believe we do not exaggerate when we say, that the upper Lakes have nothing on their waters that equals the *Ontario* in this respect. Her furniture, curtains, and drapery would adorn a palace. No lazy monarch on Earth can desire greater luxuriance than her Rosewood Sofas and chairs, her profusion of the richest carpets, her downy beds, her clean counterpanes, her rich mirrors, and the unsparing liberality of all her appointments." The *Ontario* was 242 feet long and of 900-ton displacement and cost the then considerable sum of $80,000 to build. The *Ontario* was eventually sold to the Royal Mail Line Steamboat Company of Canada and was still in service in 1873 after being sold to yet another company. She was then running between Montreal and Quebec.

In 1857, the completion of railroad lines on both sides of the lake spelled doom for the steamboat passenger industry, and Van Cleve wrote, "The company sold its boats and closed up its affairs." Van Cleve's last command was the *New York*. He wrote that she was "the finest upper cabin steamer on the lake." She was launched in 1852 and was about the same size as the company's *Ontario*. He had her in 1859 and 1860. After that, Van Cleve recorded, she ran down the river and was in service between Bangor and Boston. As of the time of his writing, she was still on the Maine to Boston run.

Van Cleve then presumably retired ashore. We know he stayed active, for he left us a wonderful legacy through his writing and art. His travelers' handbook, published in 1852 for the use of his customers (and available online at the Internet Archive, www.archive.org), shows his appreciation for the natural beauty of the lake and St. Lawrence River with a number of engravings from his own watercolor paintings. They show his characteristic lively style and his mariner's eye for detail. In its "Hints to Travelers" section, he urges the traveler "to leave home with a determination to be pleased, and to submit to the many trifling annoyances which necessarily attend nearly all modes of transit. A cheerful disposition begets a corresponding spirit in all whom it may come in contact with." Not bad advice for coping with life in general, seems to me.

Captain Van Cleve

An engraving of Kingston, circa 1850, from the *Traveler's Hand-Book* by Captain Van Cleve.

I will quote the good captain in conclusion one last time, again from his *Hand-book for Travelers*: "We now take leave of you who have journeyed so far with us, hoping that we have whiled away some few moments that otherwise might have been tedious; And wishing you renewed health…and a pleasant return to your homes, we say—FAREWELL!"

Shipwrecks during the Age of Sail

Lake Ontario looks almost oceanic on an angry day. When ten-foot waves crash clean over the breakwaters at Oswego Harbor, you can see and even feel its deadly force. A wall of wind-wrinkled water moving toward your boat as you drop into the trough and lose sight of the horizon reminds you that this is an inland sea. It's wise not to glance over your shoulder when you hear the snarl of a breaking crest close astern while running before the wind. Just focus on your job. Hold onto that helm, steer straight and keep her from broaching out of control when it hits. And when that peculiar purple-gray-colored sky moves in from the northwest with a distant rumble of thunder, jump to your halyards. Get those sails down. We can and do get killer "white squalls" here. I once watched one drive a wall of spray and spume one hundred feet high across the protected waters of Sodus Bay. I was anchored in uncertain and weedy shelter behind Eagle Island and was astonished to see three-foot waves whipped up inside the bay in literally minutes.

Imagine, then, the days when schooner crews dealt with savage winter squalls and driving lake effect snow that froze the water on their decks and knifed through their clothing with deadly cold. I have been a summer sailor for forty years. But I've seen the water steam in near-zero temperatures from inside a warm pilothouse on the Atlantic. I watched the ice build a foot thick on that ship's bow within a few hours and listened to the scrape and menacing hiss of slushy ice passing by her side. But I can't imagine sailing a wooden ship powered only by muscles and wind through such conditions. They didn't have hydraulics and hot-water radiators back then.

Shipwrecks during the Age of Sail

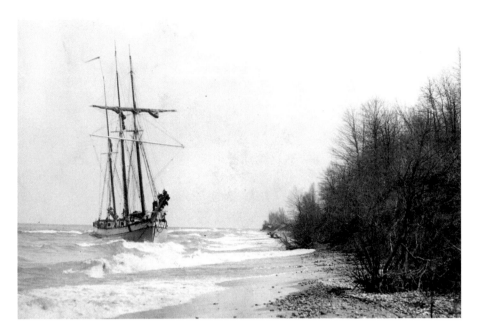

This three-masted schooner ashore in the breakers may have been salvaged. Many others in this situation did not get off. *Photo from Richard Palmer.*

Lake Ontario has seen many shipwrecks through the years. The first documented loss of a vessel here was that of La Salle's ten-ton sailing ship that was pounded to pieces by a January storm on the shores of the "Mad Cape" near the Niagara River in 1679. Since that day, hundreds of vessels, large ships and small pleasure craft alike, and hundreds of humans have died on the lake. Jim Kennard estimates that perhaps 230 wooden ships lie on the bottom of the lake today, perfectly preserved by cold water and lack of oxygen.

While saltwater mariners might scoff that the Great Lakes are mere puddles, it was precisely their lack of sea room that made them so deadly during the age of commercial sail. In a bad storm, running before a gale under reduced canvas until the wind died down wasn't an option, at least not for long. At best, a ship captain could count on perhaps twenty-four hours before he ran out of water on Lake Ontario.

Heaving to—an action that "parks" the vessel with her bow angled into the waves and allows her to drift slowly to leeward as she rides over the seas—was likewise not possible for long within the lake's confined basin. Yet the lake is big enough to make big waves. With a fetch of nearly two

hundred miles in a westerly gale, Lake Ontario is quite capable of generating eighteen footers down by Oswego. Occasional "rogue" waves half again that size can and do occur also. Such a wave could smash in and carry away the pilothouse of a small wooden steamer or simply overwhelm a schooner deep laden with coal. It happened more than once in the nineteenth century.

Fall gales were especially dangerous. They were hard to predict and quick to build and intensify as they fed on energy from the still-warm lake waters, much as hurricanes do only on a smaller scale. Often, they brought snow and severe cold with them. Sometimes the schooners' rigging iced up, making it nearly impossible to handle sails. More than one crew took an axe to their frozen halyards to shorten sail in an emergency.

The twenty-foot seas of a lake gale are also closer spaced and steeper than comparable ocean seas. Often a wave would break over the ship's rail, flooding its deck with tons of water. Before the load could drain off, another wave would add to the weight. Waves sometimes smashed in hatches and cabin doors to flood the ship. In a bad blow, crews would chop away the protective bulwarks and railings that kept cargo and men on board in order to free the decks of water. But that wasn't always enough.

Some saltwater mariners who shipped on the lakes and survived a gale vowed never to chance the lake again and went back to sea. They claimed the lake waves fell like lead on their decks, and as any swimmer knows, salt water is more buoyant than fresh. But simple overloading may have contributed to more Lake Ontario casualties than salinity. Mansfield's *Great Lakes History* notes that in the late 1800s, mortality among the canal schooners designed for the old Welland's limited depths "became almost an epidemic" after the canal was deepened. Another historian tells of how on the upper lakes, the old-time captains loading lumber would stack it high on their decks, reefing the sails to raise the booms. They would then line up the longshoremen and have them walk abreast across the ship's deck load to see if she heeled under their weight. At that point, they would stop loading and chain down the pile of boards. More than one four-hundred-ton sailing vessel was knocked down and capsized on Lake Ontario during a squall or storm.

Sometimes a top-heavy lumber-laden ship floated on the buoyancy of its cargo for several days after a capsize. On Lake Erie in 1833, the small schooner *New Connecticut* was rolled over by an autumn squall. All her crew escaped, but a female passenger, presumed drowned in her cabin, was left behind. A few days later, the hull was sighted still afloat, and shortly thereafter, the ship's owner went out in search of the *New Connecticut* with a steamer equipped to right it and tow it ashore. He found the vessel still afloat

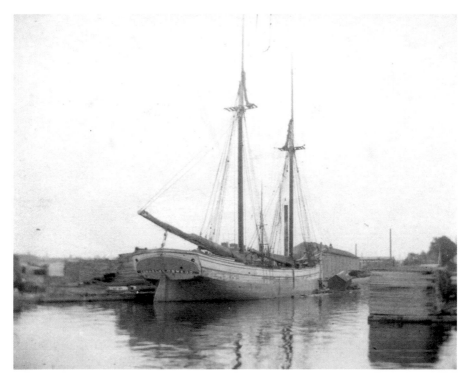

This two-master is unloading lumber in Oswego in the late 1800s. In the 1870s, Oswego handled more volume of lumber than any other Great Lakes port. Much of it went down to the East Coast for construction via the Erie Canal. *Photo from Richard Palmer.*

on its side, and as the salvagers rolled the swamped schooner upright, the lost woman emerged from the cabin, cold and hungry and very well soaked but still quite alive. She had managed to live in an air pocket in her cabin for five days.

Not until 1891 did compulsory load lines known as Plimsoll marks come into wide use on Canadian ships. Some years later, U.S. vessels also adopted these limits, which included marks for "winter loads" and summertime cargoes.

In looking back on the days of working sail, one must recall how very different technology was 150 years ago. The old schooners had no engines to help them in and out of port, and many of the harbors they used were unimproved, with narrow, shallow entrances, dangerous bars and sometimes heavy river currents to contend with. Harbor beacons and navigation lights were far less powerful in a time of oil and gas lamps. It didn't take a lot of spray, wind-driven rain or snow to dim their feeble glows into near invisibility.

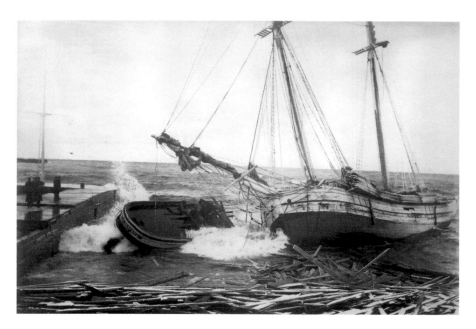

The *Flora Emma* and, beside her, the tug *Redford* ashore at Oswego in November 1893. This port, with its strong river currents, narrow entrance and big seas during westerly winds, was one of the lake's most dangerous. *H. Lee White Marine Museum.*

The old-time schoonermen had no digital chart plotters, speed logs or GPS systems to rely on. They navigated by compass, experience, memory and keen observation. C.H.J. Snider describes a young sailor's trip on a gentle summer night in the 1880s along a familiar shoreline with a light offshore wind. The boy knew from the various voices of the barking dogs, cows lowing and other farm animal noises right where his father's ship was. There were no twenty-four-hour continuous weather forecasts in that young sailor's time, and he couldn't check his smart phone for a radar image of the current weather scene. He and his father watched the sky, the look of the moon at night, the movement and form of the clouds during the day, just as I check the twentieth-century jet contrails when out sailing to see if they spread and grow wide and hazy (an indication of an approaching warm front and wet weather) or if they quickly disappear. They watched the gulls' behavior and sensed changes in humidity and wind shifts. Some ships carried barometers, but often the storms and squalls came too quickly for it to give much warning.

Even in milder months, the lake's mood could change in a moment. Sometimes it got the best of even experienced and competent captains. On a moonlit night in May 1888, the schooner *Fleetwing* was under full sail on

the cold spring lake, heading east a few miles past Scotch Bonnet light. Yet her skipper came on deck and told the mate to shorten sail. Despite the clear skies and fine south wind that was hustling them along, the barometer in the captain's cabin was dropping like a stone. "It's as if the bottom dropped out of her," declared the old man, and in response, the crew quickly turned to, hauling on downhauls and putting gaskets on the topsails and flying jib. They reefed the *Fleetwing*'s mainsail and foresail, too. Then they saw the white-hulled two-master *Blanche* sailing toward them on an intercepting course.

She was out of Oswego and bound for Brighton in Presquile Bay, ten miles or less away. With the wind aft, she was closing fast. An old account of that fateful encounter describes the moment: "The *Blanche* was booming along, her sails sharp black and white in the moonlight, wing-and-wing with the breeze, a white roll of foam sparkling like diamonds before her white bows. She had a saucy sheer, and she swam towards them like a snowy swan in a hurry."

The ships passed close enough to hail each other, but even as the *Fleetwing*'s skipper called a warning to Captain John Henderson aboard the *Blanche*, the ship had already sailed beyond earshot. A half hour later, the squall struck. It roared out of the northwest and knocked the *Fleetwing* down so far that even under shortened sail the crew thought she'd go over. After burying her rail, the *Fleetwing* staggered back up. But no one ever saw the *Blanche* again. The squall probably hit her with every bit of sail she had still flying. Her main boom would have been guyed out with a preventer to keep it from jibing as she ran before the southerly, and had the sudden wind shift caught it aback in the squall, the *Blanche* would have been gone in a moment, slammed down by the squall and driven under. Months later, a man's body arose. It was battered and nearly unrecognizable, but Captain John Henderson's mother identified it by the wool socks that still covered its feet. She had knitted them for her son a few weeks before his final voyage.

Oak-timbered hulls and canvas sails were stout and strong when new. But after a few years of hard work from early April through November, they began to weaken. After the Civil War, mechanized conveyers and trestles for faster loading and coal handling came into wide use. Sometimes the impact of tons of coal dropping from the trestle storage bins down into the hold of an elderly schooner loosened things up just enough to hasten the ship's end. The sudden sinking of the little two-master *Etta Belle* could have been a result of her recent load of coal. Her captain thought it likely she started a plank butt during loading. The *Etta Belle* was no longer young when she took on her last load at Fair Haven on September 3, 1873. She had been

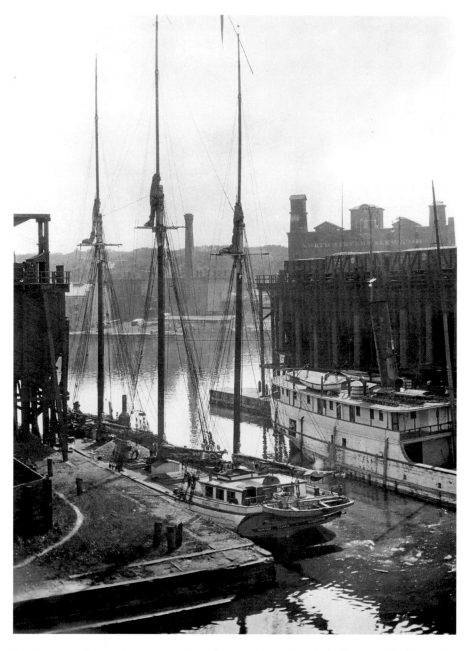

A schooner and a wooden steamer along the east side coal trestle in Oswego. The fore-and-aft rigged schooners had no yards to interfere with rapid mechanized loading structures, unlike the earlier brigantines used on the lakes. But the impact of coal loading as it landed in the hold could have loosened up some of the old-timers' timbers. *Photo from Richard Palmer.*

Shipwrecks during the Age of Sail

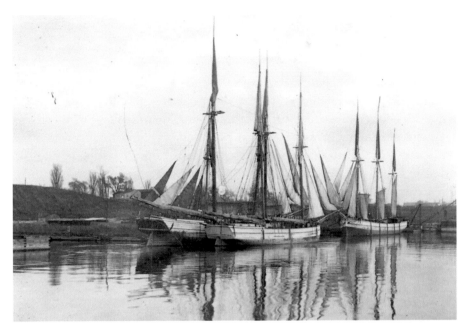

Several two-masted schooners and one three-masted canal schooner (sized to fit the Welland Canal locks) are waiting for loads of coal. Note the jibs and topsails raised or left loose on a calm day for drying. *Photo from Richard Palmer.*

rebuilt on the twenty-year-old bottom of a ship that had been wrecked and salvaged. She had been underway from the trestle for just a few hours before she sank in the calm evening waters of the lake. After her crew discovered the leak, they manned the pumps for an hour but could not keep up with the inflow. The captain gave the order to abandon ship. Her whole crew got off safely in the yawl and rowed eight miles to shore.

Unlike today's synthetic material, the cotton sails of old were much shorter-lived, as the threads were subject to rot. The frequent picturesque scenes preserved by nineteenth-century photographers that show schooners in port drying their sails testify to the care given to these all-important "power plants" by their crews. Sails were pricey items, too, and especially in the later years of the schooner era as the profit margins shrank, owners would keep patching old sails as long as they could. But when a crucial sail like the outer jib or the mainsail split in a sudden summer squall or a gale, the vessel often became difficult or impossible to maneuver. All too often, she ended up missing a harbor entrance or couldn't make her way into a safe haven and so ended her days on a stony shore.

LUCK AND CHANCE

Gear failure probably caused more wrecks than human error, but a combination of bad luck and bad management brought the career of many a good schooner to a sudden end. In the lean economic times of the 1870s following the Civil War on the Great Lakes, many ship captains who often had partial or full ownership of their schooners tried to squeeze one last moneymaking trip in before freeze-up. Cargo rates were often highest then, but so were insurance premiums and wages, thanks to the risks involved. These short days of November and December were when the lake was at its most treacherous.

The abrupt end of the schooner *St. Peter* in 1898 off the shore of Lake Ontario midway between Rochester and Oswego may have been an example of bad luck combined with human error. She was a "canaler," a distinctive type of schooner designed to squeeze through the bottleneck between Lake Ontario and the upper lakes created by the Welland Canal locks that bypassed Niagara Falls. Canalers were three-masted, generally about 137 feet long on deck and could carry six hundred tons of coal or about twenty thousand bushels of wheat. The *St. Peter* had been built twenty-five years before in 1873, a goodly age for a hard-worked coal carrier.

Times were lean for the old schooners in the 1890s when she made her last trip. Increasingly, they were losing out to railroads and steamers, and cargo rates were low. Few men wanted to ship aboard the increasingly worn-out, leaky old sailing vessels. Even with the steam-powered "donkey engines" that most schooners were by then using to raise sail or haul up anchors, there was still plenty of hard, dangerous labor involved in sailing a big schooner. Steamers offered far easier berths for seamen.

Captain Griffin shipped a trio of landlubbers for his fateful late-season run. The crewmen may have been immigrants heading west, or so at least one version of the story goes. Like many of his contemporaries, he sailed short-handed that fall, trying his best to finish the season with a bit of profit to carry his family through the long winter. From October 21 to October 25, the ship loaded "chestnut coal," 607 tons of it, for what was to be her last trip of the season back home to Toledo for winter lay-up.

The *St. Peter* was a full-sized canaler and would normally sail with a half dozen or so men. She set out with her short-handed crew on Wednesday morning, October 26, from Oswego under tow and raised sail to catch a fair easterly breeze home. The late fall day was sunny and pleasant, but when

the tug captain returned to port, he found his next tow had warped around to the other side of the trestle and was putting his sail covers back on. He was staying in port. Her captain had just received word of an early winter blizzard with seventy-mile-an-hour winds now in Chicago. It wouldn't be long before that system reached Lake Ontario.

The crew of the *St. Peter*—Captain John Griffin, his wife, the first mate and three men working their passage west—sailed on their way. The *St. Peter* was only about four miles from the lake's west end and a safe harbor when, at 10:30 p.m., the wind swung 180 degrees and started to howl. So close and yet so far, only four miles offshore, the deep loaded ship had no choice but to turn and scud before it. The crew pulled down and furled her sails, leaving just a reefed mizzen and a staysail forward, and the *St. Peter* ran for it.

When she reached Charlotte around midnight, she showed a burning torch, signaling for the services of a tug. But even as the tug *Proctor* got up steam and set out to intercept her, the scudding *St. Peter* was already lost in the darkness. Griffin deliberately steered inshore, and when off Bear Creek at daybreak, near the town of Ontario and the present-day Ginna power plant, he displayed a distress signal near the small fishing harbor. A newspaper account quoted the captain later as saying, "At this time I had no anxiety for the safety of my vessel. We tried the pumps often and every time they were found dry. She did not leak a bit." Considering that she was deep laden with coal and had only a few feet of freeboard, this suggests she was still a pretty sound vessel despite her age.

Her distress signal was evidently reported promptly, for at about 8:00 a.m., the *Proctor* received word from the Charlotte Life-saving Service station that *St. Peter* had been sighted in distress. The tug, with a lifeboat crew and a boat in tow, set out again and within a few hours was within sight of the ship. The tug was then about two or three miles west of her off Pultneyville. Then "we saw her suddenly list to port once and then repeat it. The second time she went down."

Deep laden with coal with little reserve buoyancy, she sank like the proverbial stone, and the crew and captain, all of whom were on deck, were instantly adrift in icy water and ten-foot waves. Griffin told the reporters later:

> I saw my men floating around in the water as they were tossed up by huge waves. I spoke to my wife several times after we were in the water. She seemed to have hold of something that kept her up. I had a hold of two oars and tried to get to her, but just as I would get almost within reach of her, I would be beaten back by a huge breaker. At last she said that she was tired

out and could hang on no longer. I called to her to hang on a little while longer and maybe someone would come and pick us up. Finally she said she could not stand it any longer and called to me "good-by." She threw up her hands and went down.

When the crewmen of the *Proctor* reached the scene, they found Griffin and pulled him into the lifeboat. The rest of the crew had vanished. The tug then ran on to Sodus Harbor, as the strength of the gale made it impossible to beat back upwind to Charlotte.

Today, the *St. Peter* lies in 110 feet of water, refrigerated by the perpetual chill beneath the lake's thermocline. Divers have found that the wreck is nearly free of damage and the hull remains intact. One anchor, the starboard one, remains at the cathead. The port anchor and chain is missing, and a hatchet was found buried in the wood of the ship's port rail near the cathead. The ship's cabin roof is collapsed, and damage to the vessel aft above decks suggests that she took solid water on board, probably causing her rapid flooding.

What exactly happened to her in those last moments of life upon the gray, windswept lake can only be guessed at. There are a couple theories. One is that the vessel's cargo shifted, causing her to list sharply and perhaps then be overwhelmed by a breaking wave. Another holds that she broached after a lash on the wheel broke. According to this theory, the captain and his wife had lashed the helm and then left it to lower the schooner's yawl boat, hung astern after they spotted the tug. This, to me, seems a bit unlikely given the captain's remarks as quoted above.

I'm inclined to go with the third theory mentioned by Richard Kilday in an account prepared for the Rochester Museum and Science Center, which put together an exhibit on the ship. This theory posits that the port anchor was let go in an attempt to anchor the ship so as to allow the tug and lifeboat men to come alongside. As Kilday speculates, dropping the anchor without first rounding up to slow down the ship would have caused her to override the chain. In so doing, the drag of the anchor may have caused the sudden lurch to port seen by witnesses as she broached out of control. A big wave then presumably broke on deck as she wallowed broadside to, smashing in the cabin. With little reserve buoyancy, she sank almost immediately.

It seems quite possible that this attempt to anchor might have been made without Griffin's knowledge by a panicky crewman who, having sighted the tug astern, was thinking only of rescue. Exactly what happened on that gray autumn morning off Fairbanks Point a century ago may never be known.

Fair Haven coal trestle, where the *Emerald* picked up her last load. *Photo by Edna Williams from Sterling Historical Society.*

We do know though—those of us who sail these waters today aboard small boats—that the lake in an angry mood leaves a captain and crew little margin for error or equipment failure. And luck and fate are always present to play a part in life's story on such a day. Had the *St. Peter* left port an hour later than she did, she might well have heard word of the approaching storm and stayed in Oswego. And had she departed just one hour earlier, she might have made those last four miles to a safe lee under the western shore.

For pure straight-out lousy luck, it may be hard to beat the end of the schooner *Emerald* in 1903, if C.H.J. Snider's theory about her mysterious disappearance is ever confirmed. Like the *St. Peter*, she was an old-timer, a survivor that sailed into the closing days of the schooner era. Built in 1872 on Lake Erie at Port Colborne, she had been purchased three years before her loss by an experienced, well-regarded lake captain, Frank McMaster. The *Emerald*, no longer painted green at the time of her demise, was 139 feet on deck with a 12-foot hold. She was rated by the insurers A2, and Snider says this was the highest rating any lake schooner of the time enjoyed. Those who knew her declared that her white painted hull was still sound, her spars adequate and her all-important propulsion plant—her fore, main and mizzen sails—was new.

She sailed from Fair Haven in November with six hundred tons of coal, bound for Toronto. Early one night, she was seen off the Devil's Nose a little east of Oak Orchard. The crew of the steam barge *Van Allen* sighted her lights. They were also bound for Toronto when they overtook and passed her by. The ships exchanged greetings via whistle signals, and the *Van Allen* steamed on. That was the last anyone ever saw of the *Emerald* and her crew.

The November wind blew fresh that night from the northeast. It wasn't a gale, just a good fair wind to send the old *Emerald* on her way home. But she never appeared. Days passed. Alarm, then concern and anguish, grew among the maritime community and the crew's families in Toronto. Then came reports of wreckage east of Cobourg. A deck box with the *Emerald*'s name on it had washed ashore. Soon, more wreckage was found, including a small locker door. The captain's wife recognized it by the hinges, for she herself had bought them. A woman said she had seen a three-masted schooner go down a little west of Brighton, near Presquile Bay. Had it been the *Emerald*? Somehow, somewhere between Oak Orchard and Toronto, the *Emerald* and all her crew had perished. Unseen and alone on an uncaring lake, they simply disappeared.

Many speculated as to the cause of her sudden sinking. It remains unknown to this day. No bodies came ashore. She had probably gone down very quickly in deep water. Snider has a theory, however, as to the cause of the *Emerald*'s death. If it is ever confirmed, it would be a spectacular example of the worst possible luck imaginable. Snider writes in his "Schooner Days" column that four years after the ship's disappearance, a salvage company in search of a sunken dredge found it. The dredge had been lost in a sudden gust of wind off Port Hope, and when the hardhat diver went down, he found the barge sitting upright and intact. Its massive spuds (heavy timbers that can be lowered to hold the barge in place while it works) rose to within twelve feet of the surface. And, the diver said, he saw the hull of a large schooner nearby. His air line wasn't long enough to go investigate the wreck. He saw no identification on it. Snider concludes, if indeed this was the *Emerald*, that she might have sailed across the barge's grave running before the northeaster, only to drop down in a trough onto one of those spuds. If it pierced and tore open the hull of a schooner laden with six hundred tons of coal, the end would have been quick and final. No time to get her yawl boat loose, perhaps not even time to get a lifebelt on before the cold November lake closed over her and her crew.

A note posted in the Internet says that several diving groups have gone down in the area searching for the hull. They've seen some of the tools and chains used to raise the dredge but found no trace of the reported schooner. Perhaps some wreck hunter with the side-scan sonars and tethered ROVs now available will revisit the site and find and identify that hull, if it exists. If it does turn out to be the *Emerald*, it would be cruel fate indeed, as Snider says, that she should have found the one square foot in all the lake that would spell her death.

THE HUMAN FACTOR

Sometimes human error, carelessness, hubris or inexperience cost ships and men their lives. Men rose to command at an early age, and some made rash decisions when achieving their first command. Captain Horatio Nelson Throop, son of a seafarer and named for the famous British admiral, may well have been an example of a less than prudent young commander. He built and launched his first serious commercial venture, a small two-master named the *Sophia*, in 1827 when he was just nineteen years old. A few months later in late August, he crammed her hold with one thousand bushels of new corn and steered for Oswego. Throop and his crew had a fair wind and drove their ship along under full sail that day, for the sooner the cargo was delivered, the sooner they could load another and make more money. But a few hours out of Pultneyville, the *Sophia* began to feel sluggish and seemed reluctant to rise to the following seas. The men tried the pumps, and out came a stream of lake water and corn. The grain wetted by bilge water had swelled and apparently started a plank loose from the framing enough to cause the caulked seams to leak. Before Throop could even tack about to get the bad spot out of the water, the ship's bow settled to such an extent she would no longer answer her helm. Then a wave washed over the *Sophia*'s rails and deck and rushed aft and down into her cabin. Down she went, leaving Throop and his two crewmen behind four miles from land. Throop recalled that the whole affair happened in less than two minutes. He was the last to leave the ship and was drawn perhaps fifteen feet under by the sinking schooner. He fought his way back to the surface and found a floating hatch board from the companionway. He saw one of his crew afloat, using an oar for buoyancy. However, the man soon drowned. Throop used the board as an aid as he swam to shore, and after perhaps four hours, he made it, exhausted but alive. He landed on the stony beach perhaps six miles east of Sodus Bay and began a fruitless search for his crew, stumbling barefoot over the rocks. But both men had drowned.

Throop landed ashore with nothing but the wet clothes he still wore and an $800 debt left from the building of his schooner. C.H.J. Snider, in his "Schooner Days" column, noted that Throop didn't even have a pair of shoes, as he had kicked them off to stay afloat. But with the resilience of youth, he started anew and eventually became one of the lake's most successful captains. He had learned his lesson well, too, for he never lost another ship or crewman during his forty-year career in sail and steam on the lake.

The sudden sinking of the schooner *Picton* seems to have been another case of a young captain with more ambition than common sense. It's rare

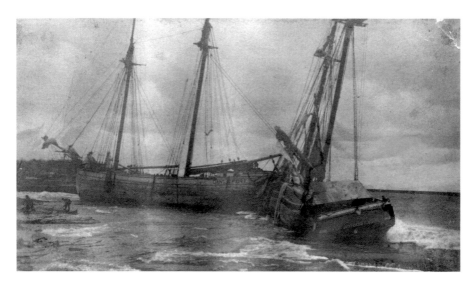

The stranded ship on the left was apparently a case of human error. The *D.G. Fort* went on the rocks at Oswego after the tug and schooner failed to make fast for towing in. Accounts as to who was at fault and who didn't tie a proper knot differ, but the result was a total loss of the *Fort* just three days after the *Baltic* went ashore and broke up in the same spot. *Photo from H. Lee White Marine Museum.*

that the sudden death of a schooner in the open lake was witnessed, but this time the crews of no fewer than three other schooners saw the *Picton* go. Young Jack Sidley (also spelled Sidle in Robert Townsend's account of the incident taken from C.H.J. Snider) had a reputation of being a sail carrier and a driver. On this trip, he had his twelve-year-old son with him. It happened on Dominion Day, as they called it then, a July morning when the lake normally smiles upon those who sail its waters.

All three ships were deep laden with coal when they left Charlotte together, with the *Picton* under full sail in the lead. But one of the witnesses paused to reef his main. He decided to reduce sail when he noticed the barometer dropping. As the trailing ship, the *Acacia*, set out again now with a tuck in her main, a strong southwest wind came blasting off the shore. Far ahead, *Acacia*'s captain saw the *Picton* luff and roll. Her sails appeared to be coming down. He looked away to wipe a bit of spray from his binoculars, and when he focused on the horizon again, it was empty. The *Picton* was gone.

Another captain sailing in company aboard one of the coal carriers said it was as if "she had fallen into a bottomless pit." He was a devout Catholic and fell to his knees on deck in prayer. When he arose, his vessel was passing though a bit of debris, a sailor's cap and a loose board or two. It was all

that was left of the *Picton*. "Four men and a boy, alive a half hour before, had gone to another world in less time than the space between a ship bell's striking," Snider wrote.

Even the old-timers suffered occasional lapses of judgment, though in reading through accounts of the times, one can't help but be impressed at how often captains and crews managed to get their unwieldy, engineless old wind wagons out of trouble and into difficult harbors. But they did screw up now and then. And with heavy gear and the ever-hungry lake, sometimes the consequences were fatal. In the 1880s, a moment of carelessness led to the death of an experienced captain and his son. It happened a few miles off Oswego aboard a family-owned vessel. As darkness fell, the *Ida Walker*, a two-master from Whitby, sailed for home from Oswego with a load of coal. She was running with the wind dead aft and expecting to be home by dawn when Captain John Allen decided to run wing and wing. A schooner can catch more wind with its mainsail on one side and its fore on the other, where the wind is not blocked by the after sail. Captain Allen ordered his older son Alfred, who was on the helm, to head the ship up into the wind to take the pressure off the mainsail. Then Alfred would go forward to haul on a tackle attached to the boom's end while the captain and Alf's younger brother Willie up on the cabin top would help push the luffing mainsail to the opposite side. Alas, when Alf left the wheel and went forward, the schooner continued to turn into the wind. Eventually, she tacked right through it, and the mainsail began to fill on the other side. The pressure of the wind began to push the big sail and heavy boom against the men on the cabin top and suddenly, as it filled, the sail lurched to leeward and swept the captain and his son off the cabin top and into the lake. Instantly, Alf ran aft and leaped into the water to save his father and younger brother. By incredible luck, young Willie managed to grab a trailing line in the darkness, and he was hauled back aboard. He and the two remaining crewmen then launched the yawl boat from the stern davits, cutting the tackles to save time. Willie dropped into the boat and pulled for the sound of the two men's shouts. But he was unable to reach his father and brother before they drowned.

Some of the most dramatic and deadly shipwrecks of the past resulted from collisions. Ships hit one another in times of poor visibility or because of sudden steering failure. Sadly, collisions also occur because of human error. Several high-profile accidents between steamers and less maneuverable schooners on Lake Ontario appear to have been examples of preventable tragedies.

The *Oliver Mowatt* was one of the last survivors of the age of sail on Lake Ontario. She was a three-master launched in 1873 and could carry

This photo taken in the later years of the grain trade shows an elevator on the west side of Oswego Harbor and part of a raft of schooners along the east side elevators. Late in the year, the pressure to get the newly harvested grain to market and make one more trip before the season closed sometimes got the old schooners and their crews into trouble. *Photo from Richard Palmer.*

seven hundred tons of coal. On September 1, 1921, she was headed for Oswego to pick up a load of coal for the Bay of Quinte. It was a clear night with a light breeze when, a few miles off Main Duck Island, the *Mowatt*'s crew sighted a freighter, the *Key West*, approaching from the east. The crew flashed a signal light repeatedly, but the freighter seemed oblivious and came on steadily toward the engineless schooner. Perhaps she expected the schooner to move out of her way, or perhaps her watch stander simply wasn't looking. Despite the efforts of the *Mowatt*'s crew to attract the *Key West*'s attention, she crashed squarely into the *Mowatt*, nearly cutting her in two. The old schooner sank in minutes. In the chaotic moments that followed, the captain and mate tried to free a jammed cabin door that had trapped the ship's cook below. Snider says, "They no doubt gave their lives," for they were drawn down with the fast-settling ship. Two sailors, one with a life preserver and one clinging to a bit of planking, stayed afloat and were rescued by the *Key West*'s crew. The captain and the mate of the *Key West* were subsequently charged for gross negligence in keeping a proper lookout.

Shipwrecks during the Age of Sail

Human error also seems to have played a role in the death of the *C.T. Van Straubenzee*, a Michigan-built three-master often known by the sailors of the Toronto waterfront as the *Benzy*. She sailed Lake Ontario for decades carrying grain, coal and lumber and in her last years was under the command of Captain Corson. The Toronto-based schooner met her end on Lake Erie in 1909, as recounted in a C.H.J. Snider column.

The night of the accident, the captain's wife slept a troubled sleep broken by bad dreams in her Hamilton home. Another woman, the daughter-in-law of the *Straubenzee*'s cook, also tossed and turned and dreamed of two ships converging. In her dream, the ships abruptly vanished. She awoke abruptly in the wee morning hours as a voice spoke clearly, "There lies the boat that was wrecked."

At that moment, the old schooner was underway on Lake Erie, bound for Cleveland on a clear, cool, starlit September night. Two men were on deck, one at the wheel and one on lookout. In the distance, the lights of a passenger steamer, the *City of Erie*, bound for Buffalo showed clearly. As the two ships gradually converged and neared each other, the mate saw the red and green running lights and knew the steamer would pass close by. The *Straubenzee*'s watch burned a flare, a wad of oil-soaked oakum on a steel sounding rod set afire, and waved it about. The steamer came on, and the mate burned a second flare and shouted at the man at the wheel to alter course as the captain came on deck and saw the looming bows of death ahead. Snider wrote that he then did something odd. He altered his ship's course to turn her broadside to the steamer, seemingly the worst thing he could do. "Hard up, for God's sake," he yelled at the helmsman, who spun the wheel in response.

They nearly made it. Snider says ten seconds more would have seen her clear. The *City of Erie*'s steel prow hit her hard and sliced deep back aft near the mizzenmast. She sank in moments, taking the captain, mate and cook asleep in her cabin with her. Two sailors up forward managed to get clear and were picked up by the steamer's lifeboats. The rest of the crew perished.

Incredibly, the inquiry court acquitted the steamer and her pilot, though the running lights and flares of the *Straubenzee* would have been hard to miss by a vigilant watch stander on that clear night. Snider theorizes that the captain chose to deliberately alter course so as to be hit broadside. The alternative, striking the steamer head-on, would have brought the heavy oak timbers of the schooner's stem up against the steamer's side, and both ships might well have been stove in and sunk. Had the *City of Erie* gone down, hundreds of passengers were at risk, and many would have died in that cold

late September water. We'll never know if Captain Corson panicked or if, as Snider speculates, he acted as a quick-thinking hero who sacrificed his ship and life to save the *City of Erie*'s passengers.

A particularly egregious example of human error that resulted in ships hitting each other occurred in 1908 near Charlotte Harbor. It involved two steamers: the *Titania*, a small excursion steamer from Buffalo; and a big Canadian steamer, the *Kingston*. The *Kingston* was on her regular run between the Thousand Islands and Toronto with 450 passengers aboard as she approached Rochester's port on a summer night with good visibility. The smaller vessel was running along the shore on her regular run between Sea Breeze and Charlotte. She had 15 passengers aboard. According to the news account, the small steamer tried to cut across the bow of the *Kingston* right off the entrance to the harbor, perhaps hoping to get into the dock to unload before the bigger steamer. She didn't make it. She rammed into the *Kingston*'s side, and "the scene along the beach and aboard the boats was one of confusion," reported the *Buffalo Evening News*. The smaller boat promptly sank, though not before her captain and several passengers managed to scramble aboard the *Kingston*. A sailing yacht, the *Julia*, which had been out enjoying the summer night, hurried to the scene to pick up people, as did the Charlotte Life Savers Crew and a private launch. A bystander on the west pier dove in and rescued a woman, and when things settled down, it appeared that no loss of life had resulted, thanks in part to proximity to the harbor.

The next morning, word went around the waterfront that the excursion boat's steering gear had failed. However, a follow-up news report noted that both ships had been moving at a brisk pace just off the river entrance, perhaps twelve to fifteen knots, and that no whistle signals were given by either vessel. Reckless and unskillful navigation appeared to have been the cause of this accident, and the *Titania*'s captain received a six-month suspension.

In the end, it wasn't always bad management or bad maintenance that did in the old sailing ships. Experienced sailors say there hasn't been a ship built that the sea can't overwhelm. Sometimes on the lake it was just bad luck that sent a good ship and her crew to the bottom. Some of the best sailors on the lake have a strong streak of humility. They understand the lake's indifference and the immutable neutrality of nature's laws when it comes to the affairs of men on its surface. The survivors, the ones who sailed for decades and came ashore to die in bed, learned from their mistakes, never let their guard down and always respected the water.

Deadly November

The impacts of weather and climate on human society can't be overstated. Along with topsoil loss from poor agricultural and forestry practices, weather and climate change have caused the collapse of many societies in the past. The twenty-first-century office worker who drives a car to work on paved roads from a home equipped with central heat and air conditioning is far less aware of rain, wind and freeze-ups than were nineteenth-century farmers or shipping industry workers. Indeed, we have never appeared to be more removed from weather in our daily lives than at present. But tornadoes, floods and ice storms still make headlines and kill people as they wreak havoc on local and regional economies, reminding us that weather does matter. Even the daily commuter must deal with heavy rain and blowing snow on his expressway route.

In the nineteenth century, weather and climate had an all-pervasive and closely monitored impact on personal and business activity. Shipwrecks and storm damage were very hard on the bottom line and the yearly profit statement. One suspects that climate change deniers in those days would have made little impression. People knew back then that weather was too important to dismiss.

Today, intense fall storms are still very much a part of Lake Ontario's localized weather. In fact, they may even become more common if climate change models prove accurate in their predictions. One scientific study documented a 12 percent increase in average wind speeds over Lake Superior since 1985. A few years ago, an October gale here generated seventeen-foot

waves on the lake and wind gusts in excess of eighty miles an hour. It toppled trees in the author's woodlot and sank or damaged a couple late-season boats still afloat at their docks in Oswego and Sodus Bay. Over the years, such fall gales have claimed many lives. The *George B. Sloan* was smashed on a pier on October 30, 1885, drowning one of the crew while attempting to enter the wave-swept Oswego channel. The schooner *St. Peter* went down just east of Pultneyville on October 27, 1898, taking all but one with her, and a Halloween blow swept young Moses Dulmage away in his yawl boat from an anchored schooner. October 2010 saw the lowest barometric pressure ever recorded for a storm other than a hurricane in the continental United States. It occurred during a Great Lakes gale that whipped up waves over thirty feet high on Lake Superior. But throughout Lake Ontario history, November has been the deadliest month.

At least a dozen November storms have made it into the record books here. Two of the three gales of November 1880 are among the most remembered, as they featured particularly poignant wrecks witnessed by many bystanders. One of these was that of the schooner *Belle Sheridan*, which "in the year of eighteen-eighty on a drear November day with coal bound for Toronto left old Charlotte Bay," as immortalized in a ballad by Mike Ryan. Her crew's demise on the shores of Prince Edward County was witnessed by dozens of helpless bystanders. The surf was so violent that the lake literally tore the bodies of the victims apart. An old news account says that "portions of viscera" were found on the beach the next morning. Among the body bits was a human heart.

That year, November began stormy. On November 1, rain and hail swept across the water, sinking the schooner *Odd Fellow* with her cargo of shingles off Charlotte and driving the schooner *Tranchemontague* ashore in Oswego. Another schooner, the *Marysburg*, with barley aboard, hit bottom while in tow in the heavy seas over the harbor bar of Oswego, taking on water and wetting 1,700 bushels of grain. The ship *Bermuda*, also while entering Oswego, took a sea aboard that threw the icebox through the wall of the cabin and then filled the captain's quarters with water. Late that month, another gale drove the schooner *Wave Crest* ashore near Frenchman's Bay after her anchor chain parted and wrecked the *Garibaldi*. It also washed a man off the deck of another schooner. But the heaviest storm was the second gale of November 1880. Many of the contemporary captains of the time said they had never seen worse. It struck on November 6 and 7, and five schooners were wrecked and the steamer *Zealand* went to the bottom with her entire crew.

Deadly November

The inner harbor at Oswego around the time of the deadliest November. *Print from H. Lee White Marine Museum.*

November has been a lethal month on all the lakes. The Great Lakes Gale of 1913, subject of several books, sank over a dozen ships with a loss of at least 250 lives. In November 1966, the freighter *Daniel J. Morrel* sank on Lake Huron, while on November 10, 1975, the *Edmund Fitzgerald* went down on Lake Superior with her whole crew. While exactly what happened to that ore carrier may never be known, according to the Coast Guard's analysis, it's suspected that she went down very quickly, perhaps in less than a minute, as there were no distress calls or indications of lifeboat launching. One theory is that she had sustained damage to at least one hatch cover before her last cruise that allowed flooding of the hold. Perhaps she had struck a shoal earlier and damaged her hull, or perhaps leaks through the hatch from the heavy seas continually washing over her deck allowed many tons of water to mix with her cargo, adding weight and making the pelletized ore more prone to shift around in her holds. Then there came one last wave, the one she couldn't lift to. The condition of the wreck as it lies on the bottom suggests that she made a sudden final plunge, perhaps speeded by a massive abrupt movement of the water-saturated cargo as it sloshed forward to help drive her under.

Both economics and meteorology contributed to making November a particularly lethal month for mariners on Lake Ontario. The shipping season traditionally ended on the lakes by December because of ice and lack of insurance coverage, so the urge to squeeze one or two last trips in to try to push the bottom line over a little further into the black before the long winter lay-up was in constant conflict with good sense and bad weather. And in November, weather patterns shift to send more gales our way. In late fall, two storm tracks begin to converge over the western Great Lakes. One brings disturbances from the Canadian interior, and the other directs lows that form over the midwestern plains northward. At the same time, the polar jet stream, with wind speeds of up to 290 miles per hour, often parks over the Great Lakes region.

Any time sharply contrasting air masses come together in close association with the jet stream and with each other, the potential for violence exists as pressure differences try to rapidly even out. When the second gale of November came to Lake Ontario in 1880, the scenario might have been somewhat as follows: Perhaps around November 4, a low-pressure system made up of warm air saturated with moisture from the Gulf of Mexico moved north. As it neared the lakes, the low deepened, with its swirl of circulation tightening even as another storm from the north dropped down over Lake Superior. As that low moved over the unfrozen water, it picked up a significant energy boost from the vast reservoir of summer heat still stored in Superior's depths. It could well be that in 1880, these storms merged (as we know happened in the Great Gale of 1913) and then combined their forces. The strengthening gale then drew even more energy from the polar jet stream as it was shoved rapidly along and continued to feed on heat released from the lakes below it. By the time the storm hit Erie and Ontario on the night of November 6, it was screaming.

The southerly winds began light that morning, and the air had an oppressive, almost muggy feel. At least two schooner men elected to stay in port that day, C.H.J. Snider wrote in "Schooner Days." The captains of the little *Maple Leaf*, with a load of barley in Black Creek, and the *Sea Bird*, anchored nearby behind Waupoose Island, both looked at the low-hanging gray clouds and listened to their intuition and the hollow moan of the wind in the bare trees on shore that morning. Then they and their crews lashed down loose gear and secured for bad weather. But elsewhere, the *Baltic*, the *Belle Sheridan*, the *Wood Duck* and a dozen other schooners, some making their last trip of the season, did decide to get underway. For several ships and crews, it was their last trip ever.

Lake Erie just to their west got the storm a few hours sooner. There, the wind came on heavy from the southwest and then from the west on Saturday afternoon, and by dusk, the temperature was dropping fast as the cold front arrived. A news account of the death of the schooner *Falmouth* near Buffalo quotes her mate, S.D. Becker, as saying of that night, "It was blowing a strong gale…and it was intensely cold, every drop of water that touched the rigging or spars freezing almost instantly." That night, heavy snow squalls swept both Erie and Ontario, and visibility in blowing spray and squalls was nil. Out on the lake, amidst waves that roared and snarled past their ships like small hills in the darkness, schooner crews struggled on icy decks in the bitter wind to reduce sail and steer down the lake, running for cover. The blast from the southwest pushed the waters of Lake Erie before it in a storm surge that raised the water level gauge at Buffalo ten feet or more, while ships settled into the mud in Toledo Harbor near the lake's west end.

Aboard the big carrier *Baltic*—on this day loaded with lumber—the crew, noting the falling barometer, was busy shortening sail at dusk. But the storm waited until the wee hours of the night to unleash its full fury. At midnight, the already strong wind began howling with hurricane force, with speeds over sixty knots tearing off large limbs and uprooting trees on the high bank under which the *Maple Leaf* was huddled. That same wind went roaring and screaming through the rigging of her sisters on the open lake. Steep, breaking twenty-foot waves rolled down the lake, and occasional "freak" waves loomed ten feet above these. The *Baltic* was now frequently spearing deep into the seas with her jib boom, a part of the ship normally angled twenty feet above the water when she was on an even keel.

Snider wrote that as the boarding seas washed her deck load of lumber overboard, the heavy planks were flung off, only to thump along the ship's sides as she ran them over. It took the mate and three men two hours to lash down the flying jib out on the end of that wave-washed jib boom. "The maddened sail would blow out and in the thick blackness of the early morning you would see the sparks fly from the chain pennants of the thrashing jib-sheets."

The waves that pounded the *Baltic* were vicious, close-spaced, steep-sided killers, characteristic of the shallow waters of the lake. Such waves with only a seven- or eight-second period give loaded ships little time to lift, clear their decks and recover before they are boarded by the next sea. About a century after the gale of 1880, yacht racer Ted Turner, veteran of some of the roughest ocean yacht races around, competed in a Chicago-to-Mackinac

race on Lake Michigan and saw waves that he said were some of the worst he'd ever experienced.

The *Baltic* ran nearly the whole length of Lake Ontario that night to make for Kingston. The next morning, with most of her canvas in tatters and much of her rig tangled and fouled, she staggered to safety. Snider wrote that her crew spent a week refitting their ship. Other schooners came into port similarly battered and glazed with four to six inches of ice. And still others were less lucky that wind-swept night and never made it to any port. They were simply battered to death, some of them on the very doorway of a harbor or safe refuge.

One of these was another lumber carrier, the three-masted *Norway*. Her hull was found two days after the gale several miles south of the False Ducks. She was completely water logged, decks swept clean and dismasted with a tangle of spars and rigging alongside. But she was still afloat on the buoyancy of her timber cargo. Her entire crew of eight men and one woman had been lost. She was lying to one anchor when the salvagers boarded her to take her in tow. No one was aboard, but they found signs of her desperate last moments in the form of axe marks on her rigging and rail. They surmised that something forward on her jib boom or bowsprit had carried away and caused her to broach to. The crewmen, in danger from the rest of the rig coming down as the helpless ship rolled in the heavy seas, perhaps anchored and were attempting to cut away the masts when one or more waves swept the hull and sent them overboard. After the wreck arrived in port and was pumped free of water, the body of one crewman was discovered below decks still fully outfitted in his foul-weather gear. As a news account of the time reported, "That the men perished heroically there can be no doubt."

Snider tells us the tough old *Norway* worked another twenty years after the tragedy. She was re-rigged without topmasts and sailed under three lowers as a tow barge. She survived another gale that destroyed one of the other two hulks in tow with her after the hawser broke.

Sometime during the night of November 6–7, the wooden steamer *Zealand* went down off Prince Edward County near Nicholson Island. She took fourteen people with her, and the loss was not discovered until November 9, when the schooner *Mary Taylor* came upon a mass of floating wreckage and a smashed stove in a lifeboat.

At Oswego, then considered the lake's most dangerous port, the gale also took its toll. Here, not one but two schooners went ashore during the gale. In both cases, the crews got off with no loss of life. The little *Wood Duck*, carrying 4,700 bushels of barley for the malt houses of Oswego, made it

The three-master *Julia Merrill*, shown here, was an "old canaler" similar to the *Norway* in rig but of lighter draft. *Photo from Richard Palmer.*

through the night, but the heavy seas and current from the river along with the wind made entering Oswego Harbor without a tug impossible. The tug tried to get to her in time and managed to heave a light line aboard, but in the rough seas, the crews were unable to secure the heavy hawser in time to tow her in. So she swept past the piers and went ashore within fifty feet of high water. *Wood Duck* drove so far onto the beach that her crew climbed out onto the jib boom and then dropped off onto the land, according to one account.

The *Oswego Palladium* wrote of the "gallant effort" by the tug *F.D. Wheeler*, under command of C.W. Ferris, to reach her in time, but alas, swept by heavy seas and constantly awash, the *Wood Duck* had lost her primary towline out on the open lake. As her captain recalled in the news article, after the first miss, "we began drifting down the lake sideways but the tug to our surprise came for us again and this time got our line." But the jury-rigged towline was too short, and the captain said, "There was a kink in it." Before it could be secured, it "ran off the timber head." The tug had nearly beached herself on the second attempt to reach the fast-drifting schooner, and there was no room for a third attempt. The *Wood Duck's* captain told the newspaper

Tugs were essential in the later years of working sail for moving the schooners in and out of increasingly congested busy harbors. They also saved a number of ships from being wrecked on shore. *Photo from Charlotte-Genesee Marine History Group.*

The singular appearance of ice hills on the pier at Oswego. Winter came early in 1880. *Artwork supplied by Walter Lewis, www.MaritimeHistoryOfTheGreatLakes.ca.*

reporter, "I think the tug did nobly, coming almost too far for her own safety; Twice she filled with water and we could not see her."

Another Canadian schooner, the *Snowbird*, loaded with lumber, went ashore a few yards away a couple hours later. Her crew was rescued by the lifesaving service, and she was sold for salvage. Surprisingly, she was later hauled off the beach, and the tough old ship lived to sail many more years and eventually fell apart in a backwater of Toronto Harbor. But the *Wood Duck* was a total loss.

Nineteenth-century Oswego was a particularly dangerous harbor for unpowered sailing vessels to enter during heavy weather. Back then, the breakwaters didn't extend out as far into the lake, so the current from the river was felt far more than it would be today. Sometimes in the fall after heavy rains, the current ran six or eight knots or more. And in a westerly gale, waves had the whole length of the lake to build up in before they hit shore here. The action of the river current and the refraction and reflection of the breaking seas in the shallows as they bounced off the jetties made for a confused, steep, chaotic sea much like a tide rip that all too often flung the schooners violently off course and sometimes smashed them into one of the jetties. Or some ships struck the river bar in the troughs of the waves and ripped out their bottoms. Leo Finn's book *Old Shipping Days* lists dozens of schooners lost at Oswego. Some missed the entrance and went ashore on the rock ledges just east of it under Fort Ontario.

A third gale hit Lake Ontario two weeks later, wreaking more havoc on the lake's already battered and hard-pressed schooner fleet. It blew the two-master *Albatross* ashore near the *Belle Sheridan*'s grave with a load of shingles and lumber and an estimated 150 tons of ice on her topsides. Her crew was rescued, but the ship was abandoned. Almost immediately after the blow, an intense cold snap froze harbors and canals. By November 24, the Welland Canal had six inches of ice on it, and many ships were caught where they lay and had to winter in far from home port. A dozen ships laid up in Oswego, while twenty more still hoped to get home. Hundreds of canalboats loaded with grain were caught in transit between Buffalo and Troy. From Little Falls came a wire that was printed in the *Oswego Palladium*: "Doing nothing. No efforts made. No boats moving. Winter down here."

The third storm drove ashore the *Garibaldi*, a 200-ton two-master built seventeen years before and loaded with coal. She hit the rocks a mile or so away from where the *Sheridan* had been pounded to pieces a few days before. The *Garibaldi* had loaded 350 tons of coal at Fair Haven and was homeward bound for Toronto on her last trip of the season. By sunset of November 27,

she had worked up to Frenchman's Bay just a short distance east of Toronto. Then the wind arose, and in the darkness, they reefed her sails and kept her plugging to windward. The ship and her gear began to ice up, and the captain ran her off for Presquile for shelter. The crew was able to pound the ice off enough to furl the frozen main after cutting the halyards, but they lost the fore, and the iced-up staysail was blown out by the gale.

All night they ran under nearly bare poles in the bitter cold, with just the outermost jib set. By morning, they had reached Presquile. Here, they managed to luff the iced-up ship into the sheltering lee and anchor. But then a gust snapped the anchor chain, and the crew's only hope was to try for the narrow entrance of Weller's Bay six miles to leeward. They almost made it, but a sudden wind shift drove the *Garibaldi* onto the bar at the entrance to the bay. She struck about noon. Within the partial protection of the shore, the ship stayed intact, but as the waves smashed against her, ice built rapidly. Rescuers managed to get a small boat from the Presquile lighthouse out to the schooner. They took off the female cook and one crewman, got them ashore and then struggled back through the freezing wind and water to pick up two more men. But as darkness fell, they were driven back from a third attempt by the breakers and wind and by a broken rowlock. Through the night, the ice built and the breakers roared as the ship's captain, mate and one sailor huddled in the scant shelter of the forward deck while the ice built around them. On Monday afternoon, the rescuers returned. They found and chopped free three men frozen in a bit of a cave under the ice. The mate was dead and frozen solid, but with him were two others barely alive. Snider quoted one of the rescuers: "Captain McGlenn was so frozen he couldn't move his legs, and he lay in the sleigh like a crooked log...for he couldn't relax his arms." The frozen man was buried in the little church cemetery with Christian rites. "He was so rigid they had to make a coffin extra wide to take his arms in and turn it sideways to get it into the grave."

The *Oswego Palladium* reported that this parting shot from November's wind gods tore away canvas, put ships ashore and dismasted schooners on both Lakes Erie and Ontario. One vessel, the schooner *Mystic Star*, was so iced up that though within twenty miles of the Welland Canal, she could no longer beat upwind and had to run the whole length of the lake with bare poles. Another schooner lost her yawl boat, as it was "smashed into pieces," and ships were "iced up as high as the cross-trees of their masts." "The fleet arrived yesterday afternoon and appeared like so many icebergs," reported the Oswego newspaper. It had been a rough year.

Deadly November

But other years were unkind too. Among ships lost at Oswego in about a ten-year period around the time of the 1880 gale, *Old Shipping Days* lists *Kate Kelly*, ashore under Fort Ontario in 1876; the *Gannett* and *Prince Edward*, lost in 1874; the schooners *Ontanagan* and *Coquette*, lost near the end of the east pier; and the *Baltic* and *Austrua*, sunk just inside the harbor. Just the year before the November 1880 gale, the *Hattie Howard*, loaded with lumber from Port Hope, tried to make the harbor of Oswego. On November 19, she hit the west pier and "went to pieces." In October 1881, another schooner hit the east pier during the night and was wrecked. Her captain thought he was steering for the end of the pier and its light when, in fact, heavy waves had extinguished the harbor beacon. The luckless schooner was instead steering for a streetlight when she hit.

And so the long, sad roll call of schooners and steamers smashed, sunk, stranded or simply swallowed up by the lake during the stormy month of November goes. A partial list of victims from the November 6–7 gale of 1880, as culled from David Swayze's database of approximately five thousand Great Lakes wrecks, includes the ninety-two-foot two-master *Albatross*; the *Belle Sheridan*; the three-masted *Norway*; and the *Bermuda*, another grain carrier bound for Oswego but run ashore and lost in Canada. Her crew got off. The aforementioned *Zealand* and *Wood Duck* also were lost. Snider mentions another, the *Thomas Street*, said to have also been pounded to pieces on Prince Edward County's limestone shore. That November, at least ten ships sank or went ashore, eight of them in a single storm, and approximately thirty lives were lost.

LARGER-THAN-LIFE LAKE MARINERS

Through the years, tens of thousands of people have interacted with Lake Ontario. Some have fished or sailed for fun, while others transported cargo or passengers, built boats or repaired motors. Some people, then and now, have simply observed this inland sea and its wildlife and sometimes dramatic weather and water movements. Not surprisingly, many stories are told about experiences upon its wide waters—stories that have gradually built up into a considerable body of folklore. Strange mirages, mysterious monsters, UFO sightings, waterspouts and phantom ships are part of that lake lore. I've heard a couple of ghost stories from yachters myself, and we all love a good yarn with a happy ending. Some of the best stories involve human heroes, pirates or other scoundrels. Bootlegger Ben Kerr; "Pirate" Bill Johnston; Ned Hanlan, the world champion Canadian rower who rescued more than one distressed mariner in his youth; and John Maynard, the heroic helmsman, come to mind. Not all the tales told of lake mariners are fantasy either. Some, like the ones that follow, feature real people.

To this day, stories survive of larger-than-life captains and crews who once sailed here. Most of these notable mariners were male, for men wrote most of the eighteenth- and nineteenth-century history around here. It's much harder to find literature about the women who supported all those brave fellows out there by staying home and raising the kids. But on Lake Ontario, as well as elsewhere, there have been a few free-spirited women with bold hearts who also left their marks on history by shipping out. As a female skipper of my own small ship, I have a special interest in their stories.

Women, despite the myth of being bad luck aboard a ship, have a long history of participation as sailors, captains, wives and cooks. On salt water, there have even been a few pirate queens, the best known perhaps being Grace O'Mally a famous Irish woman who was born at sea in 1530 and eventually became an ally of Queen Elizabeth against the Spanish. Some women worked incognito aboard ship as sailors, while a few openly participated in running the family vessel. One woman, Mary Patten, even assumed command of her husband's ship, the clipper *Neptune's Car*. Her husband became disabled suddenly just as the ship was about to round Cape Horn. Patten took the ship around the Horn and on to California, as she was the only person aboard who knew celestial navigation, thanks to her husband's teachings.

The Great Lakes have had their share of bold-hearted women who tended lighthouses, worked nets and trawls, assisted in bootlegging (see below) or sailed aboard schooners. Maud Buckley, the wife of a captain, qualified for her own license after he died and commanded the three-masted schooner *Fanny Campbell* on the upper lakes for several years.

C.H.J. Snider wrote several columns that mention women who were active participants in the business of sailing their family ships. One was Belle McPhee, who in the 1870s helped her father build an eighty-five-foot schooner and then shipped with him as cook. Snider also described a notable voyage made by Captain William Quick and his daughter Amanda. It was during the Civil War, when freights were high and profits good. The schooner *Amanda* sailed with captain, crew and its young namesake for Charlotte with a load of lumber. Once in port, the whole crew jumped ship and deserted, leaving Captain Quick with twelve-year-old Amanda to sail home, which they did, reaching port after a day and night of uneventful summer sailing in light winds. Young Amanda helped steer and cooked while her father handled the heavy gear and sails. He set all sail as the schooner ambled across the lake to her home port of Presquile, and they even paused in mid-lake to salvage and get aboard a sizable oak timber they found afloat.

Another Snider column includes mention of an indomitable female cook who intervened in a scene between the bully bucko mate and the ship's youngest crew member. The boy shipped in a three-masted timber carrier in the 1870s and suffered considerably from the attentions of the mate, who had a sadistic streak. Shortly after setting sail and becoming becalmed, a crew member lost a bucket over the side. The mate ordered the youngster into the water to retrieve the floating wooden bucket. But after doing so, the boy was unable to pull himself back aboard. He tied a bowline in the end of

the line and hung on, and the mate told him, "If you wait for me to haul you up you'll hang there until you drown."

Then the boy heard a sharp smack of flesh on flesh, and the rope grew taut as he was lifted up over the ship's ten-foot-high topsides. As he came over the rail, he saw the brawny, redheaded cook, a sister of one of the crew, with "arms like the oak timbers of the deck load," with the rope in her hands. Nearby, the mate was muttering curses as he stood with a red mark on his face where she had smacked him open handed. There was little persecution of the boy after that for the rest of the trip.

Perhaps the best-known female mariner on Lake Ontario during the nineteenth century was Minerva McCrimmon, a captain's daughter who also sailed as cook aboard the family two-master. She recently was the subject of a folk opera presented in Prince Edward County with music by Suzanne Pasternak, and her story has been written up by at least three different Great Lakes historians. Snider wrote that she was memorialized in the ballad of "Nerva of the Delaware," a song first presented in Oswego's Reciprocity House, a tavern frequented by U.S. and Canadian sailors alike:

> *She was only a slip of a girl then*
> *and scarcely twenty years old*
> *with eyes as blue as forget me nots,*
> *and a heart of 18 carat gold.*
> *But she could navigate a schooner as well as her Dad, I'm telling you*
> *Many a time I've heard him ask*
> *Nerva what ye think we'd better do?*

Though she worked as a cook, Nerva often took the helm for a spell and was said to be the only person who could make the cranky schooner steer a straight wake. She sailed with her father, Nathaniel McCrimmon, for several seasons. In the ballad, she steered the whole night through in a strong fall gale as the crew manned the pumps to keep the valuable grain cargo dry. She steered straight and true into Oswego's deadly harbor entrance, through the treacherous backwash and breaking seas and over the harbor bar. She came in safely under sail where dozens of other ships had been smashed against the breakwaters or the nearby rocks. Two years later, however, luck ran out. Minerva's ship missed the Oswego channel and drove ashore.

The end came in 1880, a hard year for the old lake schooners. That year began late, with a cold spring and heavy lake ice well into April. It ended with a series of vicious and deadly gales that left dozens of ships sunk,

A schooner approaching Oswego's narrow entrance under sail as Minerva McCrimmon once did, only on this day, the entry is made in good weather. Even then, the ship had to be well handled in uncertain currents and abrupt wind shifts. *Photo from Richard Palmer.*

wrecked or damaged. By November's end, the canals and harbors were locked up with nearly a foot of ice. History does not tell us if Minerva was at the helm on April 13, 1880, when, in a blinding snowstorm, her ship went ashore under Fort Ontario after missing the channel as had so many before her.

The lifesavers put their boat and gear on sledges and hauled them across the ice to reach the ship. But they weren't able to launch the boat to get to Nerva's schooner through the jammed-up and broken ice floes. They set up their rocket gun and fired a light messenger line out to the ship with instructions for the crew to haul aboard another heavier line for the rescue. This would be used as a sort of zip line to carry the crew one at a time back to shore in the breeches buoy. But the ship's crew wouldn't trust themselves to the newfangled apparatus, though Nerva read them the instructions on the card the lifesavers had sent over. She told them, "Why, it's as safe as a chair!" Still, they refused to try the tenuous lifeline over the freezing slush and water to safety. So Nerva got into the life buoy herself and was first to be hauled off. The skeptical men followed, and the entire crew was saved.

The ship was sold as she lay and was later salvaged, rebuilt and renamed. Minerva went ashore after the wreck and married. The story goes, however, that she died not long after her wedding of "severe congestion." Was her

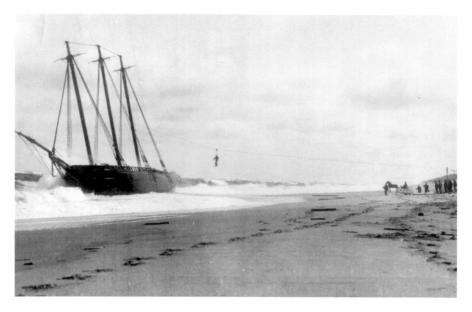

A breeches buoy rescue from a big saltwater coaster. The technique and gear is similar to that used on Lake Ontario. *Coast Guard history website.*

fatal illness somehow connected with the wreck on the icy shores of Oswego? History does not tell.

Another well-known tale of maritime folklore involving a young sailor on Lake Ontario is the true and tragic story of Moses Dulmage. His place in history was secured just a few months before Minerva McCrimmon's last voyage. However, he did not live to tell the tale. Moses was the son of sturdy Loyalist stock farmers and fishermen of Prince Edward County, that lakeward-looking piece of Ontario Province that thrusts its long, rocky fingers deep into an inland sea. His end came on Halloween night 1879, when, in a moment, his fate was sealed.

Moses was young and strong. He knew the water and had fished and sailed the lake since boyhood, and on this fateful night, the sturdy teenager was in the fo'c'sle of the recently launched schooner *Julia*. It was a cold night, with a sharp-edged west wind moaning and shrilling in the ship's rig. She was wind bound, anchored along with a fleet of ten other cargo carriers under the lee of the False Duck Islands and Point Traverse, a long, narrow peninsula that provided shelter and a good spot to wait for favoring winds. Several of the ships were home ported in Prince Edward County and manned by crews who were neighbors of the Dulmage family. Just downwind from his ship lay

the *Olivia*, whose crew included several friends. After supper, Moses asked his captain for permission to go visiting. The "Old Man" gave his assent but told him to be sure to be back early. The ship would set sail before daylight if the wind shifted or dropped.

So Moses launched the sixteen-foot yawl boat and blew downwind to the *Olivia*, where he rounded to and made fast to go aboard for a "gam." For the next few hours, the young folk sang old songs, traded gossip and told tales of their exploits in the big cities of Kingston, Oswego and even far away Buffalo. As the night deepened, the cold, westerly gale blew unabated. *Olivia*'s skipper stopped in to offer a spare bunk to his visitor. "Better stay the night; it's blowing harder than ever," he told the young man.

But dutiful Moses refused the offer. His skipper had told him to be back early. He refused offers of assistance for the upwind trip. Teenagers, we all know, are immortal. The cold, hungry water and the hard upwind row in a black night held no terrors for this youth on All Saints Eve, the night when ancient pagan harvest tradition has it that the souls of the year's dead are gathered up. So Moses slipped over the rail into the dancing yawl boat alongside and began sculling upwind. "Keep her up," cried his fellow crew mates as they lifted and swung a lantern in encouragement, for even now by its light they could see he was making leeway, being blown off by the powerful wind.

Young Moses stood facing aft and put his back and strong shoulders into the sculling of the rowboat as it pushed slowly against the wind. His heart was pounding when he reached the lee of his home ship and hailed her to take his line. Snider writes that the *Julia* was riding light that night, meaning she had no cargo and so sat high out of the water. The line that Moses had to throw aboard to a waiting crew member was coiled in the boat's bow. He had to put down his sculling oar in the stern, scramble forward and then fling the light line up to the waiting watchstander aboard the dark hull a few yards away. The wind blew it back to him.

In that moment, the lake licked hungrily against his boat's hull as the wind keened overhead in the schooner's rig. The *Julia*'s crew member fumbled in the darkness to find and toss a line to him. But it was too late. Already the yawl had blown off beyond reach. Moses lunged aft and put his oar into the sculling notch, but before he could bring the boat around, she had scudded out of reach of the *Julia* and was beyond the reach of the neighboring *Olivia*'s crew as well. "Catch the *Ariadne* and hang on," they cried to him.

By now, Moses was tired. His arms ached with the effort of sculling as he gasped for breath. The gale played with his small boat as a cat toys with a

mouse. He blew down to the *Ariadne* and hailed her. In the night, her captain below in his cabin heard faint, desperate cries. He thought someone was shouting that his anchor had let go and rushed on deck. Astern he heard the terrible pleas, "Help, *Ariadne*, help help."

"Someone is adrift," shouted the skipper. "Get the boat down!"

Moses was quickly being blown out into the implacable black lake. The crew rousted out from their bunks and, perhaps still sleepy in the darkness, botched the job. The drain plug wasn't in place, and the crew climbed down into a swamped boat. "Leave it," commanded the captain. "I'll lose you too." Perhaps he thought the lost boatman would surely catch one of the ships astern. He didn't.

There were six more ships lying to leeward of the *Ariadne*, but Moses was unable to make any of them. The wind had shifted a point or two to the north and blew him onto the open water. Thirty miles he drifted, and as he neared the low limestone cliffs of Stony Point, he steered for the lighthouse's beam. He lashed himself to the thwart and kept his numbed hands on the steering oar as he scudded before the building seas. And at some point on that Halloween night, the Grim Reaper harvested another young life.

Two days later, the keeper of the Stoney Point light found the yawl boat on the beach, just south of the light on the point. She was covered with ice, and slumped facedown on the thwart was the bruised corpse of Moses Dulmage. His hands were cut and bloodstained. Perhaps he had pounded them against the boat to keep them from freezing. A few yards away, his steering oar, also glazed with ice, floated in the slush and brash of the freezing lake.

They sent him back to South Bay. His body was taken across the lake aboard the schooner *Sea Bird*. A whole fleet of ships that had been wind bound in Oswego sailed that day, and each ship, Canadian and American alike, sailed with colors at half mast. As the schooners that were sailing west up the lake parted tacks with those bound home for South Bay, they dipped ensigns in silent salute and then hoisted them masthead high in honor of a young schoonerman who would sail no more.

Six years later, the *Ariadne*, the ship Moses had hailed so frantically that Halloween night, drove ashore just a few miles from where Moses had died. She was pounded to pieces on the night of November 29, and her captain, mate and half her crew went with her.

Some folk heroes are not universally viewed as such. Pirate Bill Johnston, a British citizen who turned against his country and allied himself with the Yankees during the War of 1812, is viewed by many Americans as a colorful, free-thinking fighter for liberty and justice. Since he set fire to a Canadian steamer as part of

Many wooden ships like the *Ariadne* were pounded to pieces in the Lake Ontario surf. *Author's collection.*

an effort to incite a revolt against the British king, the folk on the north side of the lake might understandably have a different opinion about this admittedly canny oarsman and guerrilla fighter. Smugglers and bootleggers on the lake are also subject to differing views as to the virtues of their professions. Charles Thomas Mills, aka "Gentleman Charlie," is one example of a bootlegger from the Prohibition era who was a popular smuggler, at least among his customers and business associates. Another famous Lake Ontario bootlegger stated the views of many when he said during an interview with a news reporter in the 1920s, "It is an unjust law. I have a right to violate it if I can get away with it. Am I a criminal because I violate a law the people do not want?"

C.W. "Bill" Hunt, a high school history teacher, authored several books on Lake Ontario rumrunners. His short booklet *Gentleman Charlie and the Lady Rum Runner*, published in 1999, is the source for this summary of the exploits of Charlie and Jennie Bateley, his companion.

Long before the Eighteenth Amendment to prohibit the manufacture, sale or transport of intoxicating liquors became law in 1920 in the United States, efforts to shut down the saloons enjoyed considerable support from various temperance, women's and church groups. A tax on whiskey passed to help fund the Civil War probably contributed considerably to the "barley boom" of the 1870s on Lake Ontario, when schooners brought shiploads of golden grain from the Bay of Quinte area to Oswego to supply over a dozen malt houses there. Ironically, during the U.S. Prohibition "experiment," Ontario

Province also prohibited the sale of liquor in the 1920s. But it was perfectly legal to manufacture booze there, and the distilleries and brewers did so. It was up to the bootleggers to get the stuff across the lake to the many thirsty customers who otherwise had to depend on illegal home-brewed moonshine of dubious quality. There was no law against setting sail with a load of Canadian liquor on the lake as long as the boat went directly to its foreign destination with no stops in Ontario along the way. The U.S. government tried hard to get the Canadians to modify their stance, and eventually, after several years of pressure, they did get a concession that Canadian Customs would telephone the U.S authorities whenever they cleared a cargo of booze. A few years later, Canadian Customs began refusing to give nighttime clearances for bootleggers.

However, during the first few years of Prohibition, authorities on both sides of the border turned a blind eye to violations of the unpopular law. It was easy then to bring booze in, and many a cruising yacht's crew from Rochester, Oswego, Sodus Bay and elsewhere did so. A friend of mine recalled boyhood excursions with his family to Cobourg aboard the car ferry from Rochester in the 1920s, when the usual procedure was to stuff a bottle of beer down each of the youngsters' pant legs. A small-time bootlegger and onetime neighbor of mine who smuggled beer into Oswego recalled that in the first few years of Prohibition, the men of the U.S. Coast Guard turned a blind eye to his trips as long as they got their own bag of ale bottles. But as time went on, things changed on Lake Ontario and elsewhere. The authorities became increasingly harsh in their treatment of the rumrunners. Most of the small-time smugglers dropped out, and the trade became increasingly dominated by the likes of Rocco Perri, Ben Kerr and other ruthless mob-backed bootleggers.

Lake Ontario, with its numerous north shore and neighboring Quebec distillers and brewers, was a major pathway for booze bound for both thirsty New York shoreline residents and for inland and downstate markets. Profits were huge then, as they are now, for illegal goods smuggled. Many bootleggers could make the cost of their boat in a single trip, and the markup on a bottle of beer was about five-fold during the easy days of rumrunning on the lake. Gentleman Charlie and Jennie Bateley, the subjects of C.W. Hunt's book, also inspired a musical drama recently presented at the Legend Theater in Picton titled *The Queen of the Rum Runners*. While not a lot is known about Jennie's specific actions and her role in the business, there's little doubt that she was an active participant with her partner Charlie Mills, a native New Yorker from the Niagara area.

The yacht *Lotus* was built in 1917. Like many pleasure craft of her time, she is said to have done a bit of informal bootlegging on cruises to Canada on behalf of her crew. Today, she sails Sodus Bay as Seas Scout ship 303. *Author's collection.*

Mills was an affable and well-liked smuggler who, before going into bootlegging, was a successful barnstormer for several years before he crashed his biplane into the Niagara River shortly before World War I. He survived, and Hunt says he "disappeared from public view" until the 1920s, when he became a figure in the Quinte region, where he was known as a big spender and a high roller at the poker tables. He made dozens of trips across the lake with his sturdy forty-foot cruiser, the *Adele*, a boat able to carry one thousand cases of whiskey. He hooked up with Jennie Bateley, a young widow from England who was perhaps ten years his junior, during this time. For several years, the money rolled in, and life was good as Mills and his son Edwin and other associates piloted the *Adele* back and forth between Belleville and the Oswego area. But in 1924, the United States cracked down on the lake trade and assigned several heavily armed patrol vessels to intercept the bootleggers.

The next year, Charlie and his son got caught on a September night when they were nearing shore about five miles west of Oswego aboard Edwin's

smaller speed boat, the *Winnifred*, with just fifty cases of booze aboard. About 2:00 a.m., the U.S. Coast Guard patrol heard their engines and gave chase, firing on the unlit rumrunners. Charlie and Edwin hove to and were arrested. They made their $2,000 bail easily (Hunt notes that this was twice the annual salary of many working-class folk in that day), but the whole experience soured Edwin, who dropped out of the trade shortly thereafter. However, Jennie Bateley was made of sterner stuff. She continued to crew aboard the *Adele* and also, Hunt says, suggested they start running cigarettes back into Canada for additional profits. Then as now, cigarettes from low-tax tobacco-growing states were a staple item for smugglers on the lake. (In 2009, according to a story posted on the news website Global Post, half the cigarettes sold in Ontario Province were thought to be illegal imports.) For another year, the money rolled in and all was well. But then Charlie and Edwin's case finally was tried, and the resulting fines put a big hole in the family finances. Not long after that, Charlie and Jennie nearly got caught again, this time with the *Adele*. They jumped over the side and swam for it and escaped ashore. The load was lost, but Charlie did manage to buy his boat back when she went up for auction in Rochester.

Hunt wrote that financial pressures may have prompted the couple to begin running booze into Rochester in direct competition with Ben Kerr and other, more ruthless members of the mob. Off Sodus Point one night, Charlie, Jennie and another crewman were heading home when a U.S. Coast Guard patrol boat spotted them. Despite her sedate appearance, as seen in old photos, the *Adele* was no slouch when it came to speed. The helmsman gave her the gun, and the unburdened cruiser began pulling away from the patrol. Machine gun fire sounded, and the helmsman took a hit and fell to the deck. Mills took the wheel, and Jennie tried her best to staunch the chest wound. Mills lost the patrol boat in early morning mist on the lake, but the man died. From then on, Hunt wrote, things began to go downhill for Gentleman Charlie and the queen of the rumrunners.

In 1927, Ontario Province began selling booze through government-owned liquor stores, and the brewers and distillers of Ontario could no longer legally sell to independent exporters like Mills. Some booze continued to come into the area from Quebec, but much of the Lake Ontario rumrunning trade dried up. Hunt wrote that the couple gave up smuggling booze in 1928 and moved back to the family farm in Erie, Pennsylvania. Jennie, says Hunt, outlived her famous husband and passed over the bar in Florida in the 1960s.

THE LAKE'S LONELIEST ISLAND

Though scarcely twenty miles from downtown Kingston and visited by hundreds of boaters each summer, Main Duck Island still feels wild and remote. It's invisible from most mainland points and is accessible only by boat. Few landlubbers are even aware that it exists. I have been visiting this small island for thirty years, yet it remains special. On a day of good visibility, Main Duck and its small consort, Yorkshire, first appear as a series of small dark dots that rise above a sharp-edged horizon and then coalesce into a low, solid line of treetops joined by land. Then the distinctive white tower of the lighthouse at the island's west end confirms what you already know—you are nearing one of the lake's least-known places. Main Duck has always been a sort of Brigadoon, a slightly magical place that exists just for one fair summer day before it vanishes astern and disappears again from my world. I always leave it with regret, too.

It is a rare place these days, this wild, uninhabited land by the lake. No lawns, shopping malls, giant houses or golf courses. Just wind-twisted trees, stunted sumac and lots of water snakes. Yet there is an air of romance and mystery about the place even today when it has no human inhabitants. There are ruins here. And memories still remain. I'm not the only person to be fascinated by the island. It has long been known to the commercial fishermen, anglers and mariners of the lake. Recently, a naturalist from Prince Edward County began running day trips out to the island for eco-tourists. And a big wind energy developer is interested in it.

Main Duck Island lies squarely on the route of shipping in and out of the St. Lawrence, as well as to and from the busy nineteenth-century port of Kingston. Shipping lanes and courses converge west of the island. The heavier line to the east is the U.S.-Canadian border. *Courtesy of U.S. Corps of Engineers, War Department, Coast Chart no. 21 1937.*

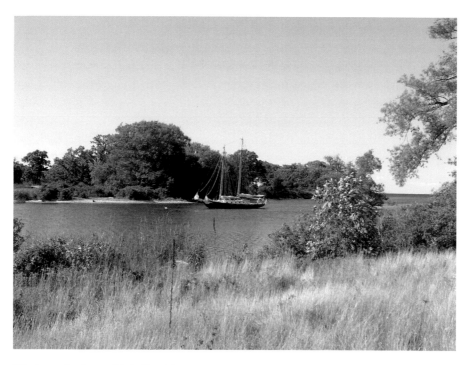

The inner harbor at Main Duck is a secure and protected anchorage. *Author's collection.*

The Lake's Loneliest Island

It's often called the graveyard of the lake, and with reason. Its rocks and outlying shoals are located right on the main shipping route between the lake and the St. Lawrence River. Vessels bound into the once busy nineteenth-century port of Kingston also had to pass near it, and in the days before radar and depth sounders, dozens of wrecks occurred on or near the island. More than once the lighthouse keeper or one of the island's winter caretakers found the body of an unknown fisherman, bootlegger or shipwreck victim on the shore and gathered it up for a respectful burial in a shallow island grave. Yet Main Duck has also served as a refuge and a safe haven to other mariners, thanks to its one small harbor.

The island mostly consists of a giant slab of stone. The glacier scraped the region clean of soil, leaving limestone bedrock and a few pockets of thin earth behind. Main Duck tilts gently north–south, reflecting the general lay of the land in the lake's northeastern corner, and tapers off underwater on its south side so even a half mile offshore, its shoals reach out to threaten the unwary vessel that cuts the corner here. But on its north side, the land drops away sharply, and the shoreline is indented with several large, deep-water coves. This asymmetry adds to the hint of mystery about Main Duck. It's different from all the lake's other islands. Though inviting to the mariner, none of these deep coves is a good all-weather anchorage. When the wind goes north in the night, the vessel is left on a lee shore with poor holding, and more than one yacht has ended up blown ashore or else hauls up anchor and departs at 3:00 a.m. for a safer port.

Main Duck does have a tiny protected inside anchorage. Once through the narrow keyhole entrance, you lie within a completely sheltered little pond fringed by cattails and reeds. A narrow strip of gravel separates this tranquil little backwater from the windswept open lake to the south. Here, even a yacht with five-foot draft can consort with carp, muskrats and snapping turtles while a boat length away bullfrogs bellow from shore and a blue heron stalks his dinner.

Main Duck's lighthouse was once one of the most powerful and important lights on the lake. It was among the last to have a lighthouse keeper, too. Today, the trail to it is overgrown and used only by hikers. Older yachters still recall the deliveries of ice and fresh-baked bread that the keepers used to make to yachts at the harbor dock. They left their two tidy cottages and well-kept lawns and gardens on the island's west end when the light was automated in 1985.

Many wrecks have left their bones on these limestone ledges over the last two hundred years. On a recent visit, a big power cruiser had just been holed after she dragged anchor, and we saw signs of her salvage still strewed about

the shore. Rusted steel wreckage and the boiler of a twentieth-century ship, the *Hickox*, remain on the shoal west of the lighthouse. Another reminder of the lake's wrath lies in School House Bay, where the wooden timbers of the steamer *Randall* are visible early in the summer before the water weeds grow up and conceal them. She had anchored here for shelter only to have the wind shift into the north and drive her ashore.

Last summer, wherever I went on the island I kept running across turtles looking for nesting sites. Mostly painted turtles and snappers, they were on beaches, in cleared grassy areas, by the path and along the shore. Several times I detoured around turtles laying eggs. As I picked my way through the tall grass at the end of the harbor, wary of stepping on preoccupied reptiles, the lake surf murmured on the gray shingle shore a few yards away and a cool breeze moved over the land. I paused to listen to the stillness surrounding me. Mixed in with the murmur of the surf, I kept hearing faint, plaintive cries, keening and what sounded like distant shouts. I suppose it was only the voices of gulls, but I kept wondering about the shipwrecks and the lost rumrunners, fishermen and mariners cast away on these ledges during storms calling for help with no one to hear them.

The mile-and-a-half hike out to the lighthouse takes you past a curious landscape. The nearly flat low-lying island's thin soil and bare bedrock don't lend themselves to rapid re-vegetation. Once mostly forested and later grazed, large areas of the island remain tree-free after being fallow for decades. Today, they form little savannahs of prairie-like grass. It's easy to imagine Claude Cole's buffalo grazing here. The trees often seem to sprout right from stone. A few traces of the island's century-long human habitation in the island's interior remain, bits of rusty machinery and the increasingly overgrown rutted road worn down to bedrock by the lighthouse keeper's jeep among them. Yet the island has long been a place of keen interest to humans. Undoubtedly, it was used by the Indians as a fishing outpost and stopover, and several different settlers farmed and grazed it. Two of the best-known island owners were Claude Cole and John Foster Dulles, secretary of state under Eisenhower.

The earlier of these, known widely as "King" Cole, was a colorful, independent-minded overlord who lived on Main Duck for over thirty years in the summer. He leased the land and fishing rights around the small harbor to a dozen or so fishermen, many of whom worked and lived here with their families during the warmer months netting lake trout, ciscoes and whitefish. Old photos show their camps, net reels and small cottages along the shores flanking the approach to the little inner anchorage.

The Lake's Loneliest Island

Cole went first to the islands as a hired gun, given the task of clearing them of wild cattle. He took his sailing skiff and rifle over and did the job but then decided to stay and try his hand there at farming. After several years, he purchased the island outright and settled in. He soon stocked his little kingdom with all manner of animals, experimenting with game such as pheasants, grouse, white-tailed and roe deer and with racehorses, cattle and even a moose or two and a few buffalo. He also tried a herd of Angora goats but found they lacked the legendary agility of ordinary barnyard goats. They would climb down onto the ledges to browse but then fail to scramble back up. Several were swept away by waves before Cole sent the rest of the flock back to his mainland farm. The buffalo were also less than totally successful. One bull swam off to another island and had to be retrieved with considerable difficulty, and after another gored a prize cow, Cole ended the experiment with his rifle.

His main profits, however, came from fishing. For a number of years, the island was home to a cheerful community of men, women and children who pulled a good living from its waters. One old-timer told me of community cookouts and good times there in the 1940s. But the fisher folk weren't fond of the buffalo, which were considered a definite hazard when the cottagers had to make their way through the night to an outhouse. For a time, there was even a small school on the shores of School House Bay for the island children.

"King" Cole presided over this small fiefdom for over thirty years and was well regarded by most of the visitors who stopped by the island during the summer. Born on Big Island in the Bay of Quinte, he divided his time between a farm in New York State near Cape Vincent and his island. He was a hospitable ruler, and a number of reporters visited the island in the 1920s and '30s to listen to his many stories. One wrote, "The Main Ducks with or without its wrecks will be interesting as long as its dominated by so genial a king as Claude Cole."

As several summer visitors who published articles about the island pointed out, Main Duck was a paradox—both a trap for the unfortunates whose ships blew onto its rocky ledges and a refuge and place of peace. A 1927 account of an April storm included descriptions of large pieces of steel roofing ripped from barns sailing through the air and numerous timber blowdowns: "So violent was the gale that large whitefish and herring were thrown on the beach twenty yards from high water mark. A wagon load of good whitefish could have been picked up in a short time." Today, as you walk the island's shores, there are few whitefish to be seen, but evidence of the huge winter

The remains of what has been said to be Claude Cole's cottage located near the anchorage. *Author's collection.*

waves is everywhere in the form of driftwood and rounded beach stones thrown many feet inland. Yet on a summer day, Main Duck's shore can be silent, sun-washed and still. Then the island is a place of peace where one can bask on the hot rocks after a swim and stare into glass-clear water, pondering the past until the silence, sun and still water induce a trance-like meditation. How different the island was eighty years ago, as it bustled with fishing and farming activity under Cole's reign. And how different it would be during a wild winter night of wind and waves. An old newspaper article summed it up: "Mr. Cole is the proprietor of the Duck Island Dairy and the butter manufactured there is said to be the finest sold in Canada. During the Summer months life on the island is like a long holiday, and the monotony is broken by the arrival of fishing parties and the passing of all kind of sail craft. But in the winter, the days and nights are long and the life, to many, would be found dreary enough."

Cole was a very competent mariner, though even he got into a few scrapes with his seaworthy boat as he ran people and supplies back and forth between

The Main Duck light on the island's west end was once among the most powerful on the lake. The present tower was built in 1914. *Author's collection.*

Main Duck and the mainland. He actively advocated for a wireless station and additional safety and rescue gear on the island, and more than once he risked his own life and property to go to the rescue of anglers or yachtsmen in trouble on the lake. He is also said to have been in sympathy with the numerous bootleggers who used Main Duck as a stopover while heading to Oswego or other south shore drop-off points in the 1920s. Gentleman Charlie Mills was a regular visitor to the island, as was Ben Kerr, the "well-known exporter." In early March 1929, Kerr departed Bellville with a cargo of liquor aboard his speedboat the *Pollywog* and vanished. His wife contacted Cole and asked him to search for the missing boat and crew. Cole, then still ashore at his mainland home near Cape Vincent, chartered a plane from Watertown and searched the lake from Presquile to Main Duck and all of

the American islands. He turned up nary a trace of his old friend. After landing, he made inquiries but was unable to learn anything definite as to Kerr's fate. He wrote Mrs. Kerr, "It would not surprise me much if the two men in question were unloading near the American shore that a machine gun might have been turned on them, or they might have hit a large cake of ice and gone down." About a month later, Cole received word from Kerr's brother that the bootlegger's body had been found on the shore near Cobourg. Perhaps the lake had claimed him before a "business associate" could do the job.

Cole ran his husky wooden fish tug back and forth between Cape Vincent and the island, and historian Willis Metcalfe says that his wife, Annie, was an able helmsman as well, often taking the tug with its load of fresh fish into Cape Vincent. Cole knew how dangerous the lake could be, and his boat was once frozen in a mass of ice while trying to reach the island in early spring. It took the crew four days to cut their way through the ice jam to get to the island.

The Coles wintered on the island a few times and in later years left their "kingdom" and its livestock in the care of their son Cecil, his wife, Edna, and various other companions and caretakers. Besides looking after the animals, the caretakers also cut and stored ice for next summer's fishing season. In the winter, the only means of communication between the isolated island and the outside world was by letters sent over to the mainland on small rafts equipped with a few evergreen branches for sails. A February 9, 1933 item in the Watertown paper reported on word received from the island by Mr. and Mrs. Cole. It read, in part:

> *Dear Father and Mother, The wind is down the lake and blowing hard so we are sending a raft and hope someone will find it soon. We had a fine run up and found everything fine here. There is just a little ice in the upper end of the pond. Cecil ran the tug up in the mud and has her engine nearly laid up for winter. Clifford had everything in good order. We had heavy wind, rain and sleet last night we'll be looking for dad and Bill Stanley early in the spring. P.S. Cecil says to bring some cigarettes—he may be short by March. Signed Cecil and Edna*

Another later letter written by Edna about six weeks later was also recovered. On that January day in 1933, she wrote to her in-laws: "Well this is almost a summer's day so we'll send you a letter to tell you we are all well except Mary. She seems to have the mumps. There is very little ice in the pond…Cecil and Clifford built a new ice sled in case we get some cold

The older of the two keepers' cottages located on the island. Some efforts were underway in 2011 to stabilize and save the buildings. *Author's collection.*

weather. It doesn't look that way now. Hope you are all well. The men are in a hurry so good-bye. Love to All Cecil and Edna."

Then as now, getting back and forth between the island and the mainland could be a challenge. In the spring of 1919, before the Coles had built their own vessel, Cole hired a boat for the first trip of the season. He took along a couple of fish hatchery workers who planned to release a number of fish fry, and they set out from Cape Vincent one calm, mild late March morning. But March weather is fickle, and after reaching the island to check on the caretakers and releasing the fish, they decided to head immediately back to the mainland, as the wind was picking up.

About an hour from safety, the engine quit. According to the news story, the carburetor went wrong. The men "took the engine down and started to repair the wrong," but before they could finish the job, it was too dark to work. Rolling and bouncing around in the increasingly cold wind, they opted to anchor. It snowed and blew all night, and no one got any sleep. Says the local paper, three of the four "experienced the sensation of seasickness

though all were trained sailors." They stuffed old rags into one of the fish hatchery cans, soaked them with kerosene and burned them for warmth. At some point, their anchor line broke, setting them adrift. After a miserable night, daylight finally arrived, and the engine was speedily "made right" so they could get home.

Though that particular passage had a happy ending, others ended near the island under less fortunate circumstances. Cole kept an empty house stocked with emergency supplies in the winter for the use of anyone who washed up on the island when no one was there. And he had plenty of stories of wrecks both witnessed and legendary that he enjoyed telling visitors about. One was of a French vessel that hit Charity Shoal and drifted onto the island. The legend goes that she was heading to Fort Niagara with supplies and a pay chest of gold for the troops in late fall around 1750. She was sinking fast after hitting the shoal and so was run ashore. The following spring, searchers found on Main Duck a row of fresh graves and the remains of a man seated near shore and looking out at the lake. Presumably the last survivor who had buried his fellows had wandered off to die alone. Perhaps he died watching the horizon for a rescuing sail. The gold, if it ever existed, was never found, though history holds that a large boulder marked with a date and an arrow marked its burial spot. If that rock is still there, it's too well concealed in the brush and shrubbery for me to find it.

C.H.J. Snider saw the rock, but he put little stock in the buried treasure tale. In the 1930s, when he was cruising the lake with his own yacht, the northeasterly point near the harbor was still called Graves Point. Snider noted that ninety years before his visit, the graves were still obvious. He recorded his own observation of a half dozen additional graves farther to the west near the high stone "bluff" on the island's north side near the Dulles cottage ruins, and he noted that various relics such as military buttons, rusted bayonets, grapeshot and cannonballs had all been found around the harbor. He also described a few bits of wooden wreckage, including part of a rudder, that were still visible underwater in the little cove near the present-day inside harbor. There were signs such as erosion by sand and rock that suggested the timbers had been there a very long time.

Another visible reminder of the lake's wrath lies in the popular outside anchorage of School House Bay: the wooden ribs and planks of the one-hundred-foot steamer *Randall* that sank in 1920. She had anchored here for shelter on November 16 only to have the wind shift into the north and drive her ashore. One account says her stern hit a rock, and her engine lifted up and she broke in two. The crew of four scrambled forward where the bow

The cove where the *Randall* lies. *Author's collection.*

was still above water and remained there for ten hours, washed by heavy seas and lashed by a November northeaster. The ship's company finally made it ashore by means of a hatch cover and were found by one of the lighthouse keepers. The four men stayed with the lighthouse tenders for nine days before they were picked up. Today, rounded, polished lumps of coal still wash up on the beach by the cove.

Cole died in 1938, and a few years later, John Foster Dulles—then a successful Wall Street lawyer who grew up in the Henderson Harbor area—purchased the island. As a boy, Dulles enjoyed fishing, sailing and swimming. When he was thirteen, his grandfather gave him a small cat boat, and he and friends sailed her out to the island to explore it. An obituary of Dulles posted at the Arlington National Cemetery website states that he and his wife fell in love with the island during their summer sailing expeditions on the lake: "They liked to withdraw to the privacy of their island and rough it, hauling water, chopping wood, fishing and cooking. Mr. Dulles took pride in his cooking, especially fish."

The future secretary of state and cold war warrior against the "Godless terrorism" of the Soviets visited Main Duck during summers and built

All that remains of the Dulles cabin is this heavily vandalized chimney. *Author's collection.*

a small cabin on the north shore's high overlook. He had the Canadian government declare the island a port of call so he could fly directly to it without bothering to check in at Kingston first. He is remembered as facing

criticism and skepticism in his beltway dealings with senators and statesmen, but inevitably, he would prevail. The powerful and controversial secretary of state was a man of paradoxes. He was gregarious but worked alone, says the website obituary. He navigated the intricacies of international politics with apparent ease yet liked the simple life. On Main Duck, he enjoyed clearing brush, cutting wood and fishing. An old neighbor of mine who was active in local Republican Party circles told me that he was once invited to go duck hunting on the island with Dulles and company. Here, wealthy and powerful associates from Washington, D.C., and elsewhere also came to hunt and fish. Perhaps they told stories and made deals over their drinks that twisted the fates of untold multitudes of ordinary men and women as they sat around the little cabin's fireplace. Today, only the chimney and part of the cabin foundation remain.

After Dulles died in 1959, the island was purchased by another American, Bob Hart, who had worked for Dulles. He ran a hunting lodge there. In 1977, the Canadian government bought it back and declared it a park. I first visited it in 1980. Today, no one lives there. People stop off and drop anchor here only briefly for a few hours or a few days in summertime. Yet the island's allure and sense of mystery remain strong. A Picton-area naturalist, in partnership with the Ducks Dive Charters, offers day trips out to the island, and there is an effort underway to preserve the empty, vandalized lighthouse keepers' cottages.

A proposal for a $710 billion offshore wind farm, to be located on the ledges south and west of the island, surfaced a few years ago, though as of this writing in early 2012, it was on hold due to a Provincial Moratorium. If constructed, it would forever change the wild island. Electricity produced by the wind farm would be sent to the mainland via underwater cable to the Lennox oil/gas power plant located on the Bay of Quinte near the Upper Gap. From there, it would be sent to the Toronto area.

A company called Trillium Wind Power has proposed this project, perhaps the largest Great Lakes wind farm yet. If it does go through, it'll be another example of the importance of Lake Ontario to our regional energy economy. The lake's abundant waters already cool and re-condense steam at sixteen nuclear reactors on its shores, as well as at several coal- and oil-fired plants. And huge hydro dams at each end of the lake produce almost five thousand megawatts of power each year. (See next chapter for more on this.) I published a small book, *The Great Atomic Lake*, in 2002 after public utility deregulation changed the energy landscape forever. Then and now, I remain a skeptic of splitting atoms and generating heavily subsidized and

In 2011, the province placed a moratorium on new wind farms pending more study. This sign is on Amherst Island, about twenty miles from Main Duck. *Author's collection.*

massive amounts of radioactive waste to boil water. Wind power seems to me one of the less obnoxious ways to light up the computer screen. But I and others hope that damage to bird and bat migration flights from turbines will be minimized. I personally view the aesthetics of a huge wind farm just offshore from Main Duck as no worse than that of the massive hulk of Nine Mile Two nuke's cooling tower that looms over the lakeshore east of Oswego. However, a huge offshore wind farm would change the character of that lonely place.

Almost every summer, my co-captain and I continue to make a "pilgrimage" to Main Duck with our sailboat. Its future, like our own, is uncertain, but I hope it will remain a Brigadoon for those respectful of nature and small wild places for many years to come.

THE SEAWAY SYSTEM

Boon or Bungle?

O ur passage through history on Lake Ontario concludes with a short
account of the St. Lawrence Seaway, as seen from a maritime and
ecological viewpoint. Most histories of this project have focused primarily
on the economic aspects of this engineering "triumph." Was the Seaway
System project and its power dam an awesome, breathtaking feat of modern
engineering by the genius builder of New York State, Robert Moses, and his
Canadian counterparts? Or was it the worst thing that ever happened to the
Great Lakes? Let's look back on fifty years of Seaway history for an answer.

The St. Lawrence Seaway and Power Project, dubbed the greatest
construction show on earth, was and still is controversial. Global
politics and a hunger for cheap electricity from hydropower motivated
its construction. Today, the hydro stations continue to produce some of
the cheapest electricity in North America. But many of the ship transit–
related engineering structures in the Seaway System are nearing the end
of their fifty-year designed life span, and some policy makers are asking
at what price should the locks and channels be maintained and upgraded.
Its construction also led to unexpected consequences and heavy economic
costs after dozens of different fish and invertebrate hitchhikers entered the
Great Lakes in ocean vessel ballast tanks and made themselves at home.
And to this day, Lake Ontario homeowners with waterfront property
wrangle with ecologists and shipping interests over the Seaway's control of
water levels. In a time of concern over greenhouse gas emissions and land
transport costs, is the Seaway more important than ever to our security and

environment? Or, as some say, is it a monumental billion-dollar boondoggle and environmental disaster?

The Seaway was a big project. It consists of two U.S. locks in Massena; four Canadian locks at Iroquois and down near Montreal; and eight locks on the Welland Canal that bypasses Niagara Falls, along with the dredged channels, flow control dams and other structures. It took ten thousand workers five years to build it, and they used three million cubic yards of concrete and enough steel to circle the equator to do it at a cost of $470 million back in 1959, when $1 million was still worth something. Today, ships up to thirty-five thousand tons can pass through the system. Most are either Canadian lakers or international vessels carrying lower-value bulk cargo. About forty million tons of cargo a year goes through the Seaway on average.

The Seaway's construction was a cooperative effort between the United States and Canada. Trade has always been the bond that formed a friendly alliance for well over a century between the two countries. However, cold war concerns about moving materials of strategic importance on a waterway exclusively under Canadian control also provided motive for American interests to help build it. The Canadians had wanted the power dam and improved shipping channels in the river for years, but railroad and trucking interests lobbied against the waterway in Washington. It wasn't until the Canadians decided to move ahead on their own that the United States kicked in funding and began cooperative design work. Today, we mostly associate the Seaway with shipping, but an important motive for building the giant water control structures that made it possible was hydropower production.

The constant flow and huge volume of water from the natural reservoir of five great lakes made this an ideal place for the Moses Saunders Power Dam, which today generates about two thousand megawatts a year, roughly as much electricity as Oswego's Nine Mile One and Two nuclear plants combined. It puts out as much power as the giant Hoover Dam potentially could on the Colorado River before drought-reduced flows and even threatened to shut those turbines down. Year after year, the St. Lawrence, backed by the biggest reservoir of fresh water in North America, cranks out a relatively constant amount of electricity as a base load power producer. It's some of the cheapest power in North America. Municipalities buy it at a little over one cent a kilowatt hour—considerably less than the average U.S. rates of about ten cents a kilowatt hour.

After it opened, ships began passing through it, some going all the way to Duluth 2,300 miles "upstream" for wheat. Twenty-five million tons of cargo went through the locks that first season. By 1979, eighty million tons

The dam that regulates water levels on the St. Lawrence Seaway is visible behind the lock. *Author's collection.*

of cargo were being transported through it. For half a century, the Seaway has been a fuel-efficient and cost-effective route to move bulk cargo. There's no doubt or controversy about that. A recent study funded by a coalition of shipping industry interests showed over $10 billion in direct business revenue generated by the system in 2010. I visited the New York side of the big power dam to write a magazine story about twenty years ago and was told the project had paid off its construction bonds early and was expected to produce power at a profit for the state for perhaps another century.

Several energy intensive factories also located in the Massena-Cornwall area to take advantage of the low-cost electricity from the power dam. Things looked great for the local economy and residents (except for the Mohawks, who had to vacate ten islands and a considerable part of their small mainland reservation, Akwesasne, thanks to flooding and dredge spoils from the project). Good-paying jobs at Reynolds, Alcoa and GM kept the area humming. But after a few years, some of the farmers noticed that their cows were dying of fluoride poisoning from the aluminum smelting plants. Then a Mohawk midwife noticed an unusual number of

When elvers migrate up the St. Lawrence from salt water, they are a bit bigger than the glass eels shown in this photo of a New England stream. *Photo supplied by Tim Watts, www. glooskapandfrog.org.*

babies being born with cleft palates, no hearing and other abnormalities. Studies soon linked the birth defects to PCB contamination from the GM foundry, where from 1958 until 2009, GM made aluminum cylinder heads. The factory is now home to a Superfund site. To this day, though no studies have been done, a large number of Mohawks living near the site suffer from cancer, thyroid disorders, heart disease and other illnesses that they believe are linked to the PCBs and/or other toxins produced by the facility.

Other costs of the Seaway became evident only after a few decades had passed. The dams blocked spawning runs of sturgeon, eels and other fish from moving up or down the river. An eel ladder was built at each side of the power dam for the young eels to use, but the eel population crashed for reasons unknown. Some fishery workers suspect that the culprit is the dam, whose turbines are known to be very hard on the adult eels running downstream to the sea to spawn. They have to pass through the turbine chambers and often don't make it through alive. The timing of the eel population crash is certainly suggestive; it happened just about the life span of a long-lived eel after the dams were built.

Still, one could have overlooked the loss of a few old slimy eels, which by one estimate may have formerly made up half of the biomass of Lake Ontario's inshore fish community and supported a big commercial fishery on the lake and downstream in Quebec for generations. (In 2012, fishermen were getting $2,000 a pound for young eels on the Maine coast.) And perhaps two more Superfund sites courtesy of Reynolds Metals and GM up along the St. Lawrence River were an acceptable trade-off for all that low-emission hydropower being cranked out each year with zero radioactive waste as a byproduct. One source says the power dams have prevented 175 million tons of greenhouse gas emissions to date. But the ballast water hitchhikers using the Seaway really started people asking about the cost-benefit analysis for the Seaway.

So-called invasive species are a huge problem worldwide. In the United States alone, one study estimated that unwanted exotics cost us over $130 billion a year. And nowhere have invasives hit the native web of life harder than on the Great Lakes. A Wikipedia article lists 10 "notable" invasives, and the zebra mussel comes in at the number-two spot. This little shellfish and its near twin, the quagga mussel, showed up in Lake Ontario about twenty years ago and have been estimated to cost the economy up to $1 billion a year in direct and indirect costs. And this is just one of more than 180 exotics that have settled in to call the Great Lakes home. Today, we have water fleas from the Caspian Sea, little scuds from the Chesapeake, Chinese mitten crabs and Black Sea flounders in the lakes. Lake Ontario has become an ecological mix of hardy adaptable foreigners that all too often crowd out the less competitive natives.

"Aliens" have had a huge impact on the lake's ecology, none more so than the zebra mussel. It has had such a profound effect that it has been called an ecosystem engineer. This highly efficient filter feeder competes directly with the zooplankton that are important food for larval fish. It was able to spread quickly throughout the Great Lakes after arriving in a ballast water tank probably from the Caspian Sea region because, unlike native clams in the lake, its larvae are free floating and abundant and so can disperse rapidly. It colonizes hard surfaces like rocks and boat bottoms and may survive for several days out of the water. It has expanded its range through much of North America since it established in Lake St. Clair around 1988. Zebra mussels have almost certainly been spread to some locations like Lake Mead via boat bottoms or live wells.

The zebra and quagga mussels, by their vast abundance and efficient filtering of one-celled plants, divert huge amounts of energy from open lake

Zebra mussel shells piled up on the south shore of Main Duck Island in 2004. *Author's collection.*

food chains to the bottom of the lake. This spells trouble for the few native plankton-feeding fish we have left and also for the alewife, another alien originally from salt water that is the main food source for those big salmon the recreational fishery depends on. A few species of fish eat zebra mussels, but in general, their ability to reproduce far outweighs the ability of native birds and fish to control the species. The zebra mussel is also strongly suspected of playing a major role in the increase of deadly botulism outbreaks that have killed tens of thousands of birds and countless fish on the Great Lakes.

After the Seaway opened, saltwater vessels could make the trip more quickly from their home port to the lakes than previously. The ships were also bigger and carried more ballast than in pre-Seaway times, and this, along with the shorter transit times and possibly reduced pollution overseas, increased the probability of bringing in a viable population of unwanted hitchhikers. Scientific studies estimate that up to 70 percent of the invasives in the Great Lakes today got here via ship ballast water since the Seaway opened.

Lake Ontario was particularly susceptible to "invasion" because it had a relatively simple ecosystem with a fairly low diversity of native species. The

lake is very young geologically speaking, having been formed just six to eight thousand years ago. From an evolutionary perspective, that isn't a lot of time for specialization and diversity to build up. Like islands with their relatively low number of species, the web of life in northern lakes in general is less resilient to begin with. By 1959, Lake Ontario had already been profoundly disturbed and degraded by human activity and was highly vulnerable to hardy exotic immigrants.

While estimates of economic damage done by these unwanted critters are tricky, one guesstimate by a team of Cornell scientists was an annual cost of about $120 billion a year to the U.S. economy from all invasives on land and in water alike. Much of the cost associated with the zebra mussel on Lake Ontario has been because of its affinity for intake pipes. Cleaning the pipes of power plants, water plants, factories and other users of lake water costs money. NOAA's Great Lakes lab estimated a few years ago that the Great Lakes water users were spending somewhere between $100 and $400 million a year on zebra mussel fouling, dumping large amounts of chlorine into the water to do so.

All those numbers have led some people to suggest that the Seaway's benefits no longer outweigh its costs, especially if proposals to expand it to accommodate standard-sized saltwater container ships are funded. According to the U.S. Army Corps, the Seaway locks can only accommodate 13 percent of the world fleet of ships and expansion is essential to keep the Seaway "competitive." But enlarging the locks and digging deeper channels is a pricey proposition, and opponents argue that it may not necessarily attract more commerce. They also point out the U.S. Army Corps has an obvious bias in favor of new construction projects and its projected increase in traffic after expansion is highly suspect.

Today, ships exchange ballast water at sea or flush out their tanks before entering the lakes. There are also systems that can treat ballast water using UV light or other noncorrosive chemicals that are being installed in a few vessels. This all costs money, of course, and the shippers would rather not have to pass the cost on to their customers. But it does eliminate most of the unwanted hitchhikers. As this book was written, tank treatment standards were being issued by the U.S. Coast Guard, and with them will likely come better, more affordable technology given a large new market for it.

So how environmentally friendly is shipping on the Seaway? A truck uses one gallon of diesel to move a ton of freight fifty-nine miles. Railroads are up to five times more efficient, while a barge or ship uses a gallon of fuel to move a ton of cargo five hundred miles. In considering trucks versus ships,

The *Stephen B. Roman* was originally built for the short-haul freight business. Today, she hauls powdered cement from the quarry at Picton to various locations on Lake Ontario and Erie. *Author's collection.*

Erosion of the lakeshore occurs even on calm days, though it is much more severe during storms. Higher lake levels, along with a lack of shore ice during mild winters, aggravate the problem. The concrete chunks are former cottage foundation. *Author's collection.*

there are also the very considerable environmental and water pollution costs associated with roads and polluted runoff from the same. Proposals for short-haul shipping within the Great Lakes, where ships and barges would move commerce around by water that now travels on Highway 401 or the New York Thruway, make sound environmental sense. They wouldn't need an expanded Seaway system either. But they do need a structurally sound and reliable one. Unfortunately, at today's oil prices and given current institutional pressures in favor of trucks, roads and continued oil consumption, it might be a while before we see a viable short-haul shipping industry again in place on the lakes as it was in the 1940s and '50s. Back then, small- to medium-sized package freighters delivered all sorts of goods from mousetraps to school buses around the lakes. One of the last of these was the vessel that now calls at Oswego each week with a load of powdered cement from the quarry at Picton. She was originally built in 1965 to move high-value cargo on pallets around the lakes. She was the last package freighter designed for Great Lakes commerce and was launched in 1965. She was remodeled and renamed the *Stephen B. Roman* in 1982 and now hauls bulk cargo, like almost all the other ships on Lake Ontario.

The construction of the dams on the Seaway also led to another controversy—that of lake level control. Thanks to the power dams and flow control structures associated with them, Lake Ontario's outflow can be regulated with considerable precision, at least over a period of weeks and months. Inflows from the unregulated upper lakes and the short-term movements of water when strong winds pile it up along one or another shore are another matter. Humans still can't do a lot about the short-term changes associated with storms and floods. In general, one can say the folks who live on the lake in high-value waterfront homes want the water low so as to reduce shoreline erosion. The shippers want the water as high as possible so they can carry more cargo through the channels and locks. The power dam operators want a constant maximum flow through their turbines. The marina owners want it just right—not too high to flood the parking lot but high enough for the boaters to use their docks. And some environmentalists want the water levels to vary throughout the year, as they historically did before the dams were built. This would benefit a number of plants and animals that live in protected waters and wetlands along the shoreline. I've gone to a couple of meetings held by the International Joint Commission (IJC), the folks who do the regulating, and the homeowners and real estate interests can get pretty heated and even downright testy about the whole business even as the IJC tries to balance all the competing and conflicting needs and desires.

The remains of this lakefront cottage floor will soon be part of someone else's beach. *Author's collection.*

People like their water levels to be constant and predictable. Homeowners get upset when the level is too low to use their boat docks, and they get really upset when high water eats up their shoreline and undercuts their houses. Unfortunately, natural systems don't always work in simple, predictable ways. When we view the history of the Seaway and the complex changes that we have experienced since its construction, is there a cautionary lesson about geo-engineering proposals to counter climate change in all this? As interest in geo-engineering heats up (pun intended)—and software engineer Bill Gates is said to be kicking in funding—some of us with an ecological background see trouble ahead. The co-chair of a $14 million study of Great Lakes level control published in 2012 for the IJC said in a news release about his study group's work, "Anything we do to help somebody will hurt somebody else. People need to learn to live with it." Learning to live with it is called adaptation. Those who adapt evolve and survive. As millions of years of history show, those who insist on doing it their way don't.

Sources and Further Reading

Cooper, James Fenimore. *Ned Myers: A Life Before the Mast.* N.p.: Richard Bentley, 1843.

Gateley, Susan Peterson. *Passages on Inland Waters.* Wolcott, NY: Whiskey Hill Press, 2004.

———. *Twinkle Toes and the Riddle of the Lake.* Wolcott, NY: Whiskey Hill Press, 2009.

Hunt, C.W. *Gentleman Charlie and the Lady Rum Runner.* Belleville, Ontario: Billa Flint, 1999.

Lossing, Benson J. *The Pictorial Field Book of the War of 1812.* New York: Harper and Brothers, 1869.

Mansfield, J.B. *The History of the Great Lakes.* N.p.: J.H. Beers and Co., 1899.

Snider, C.H.J. *In the Wake of the Eighteen Twelvers.* N.p.: John Lane, 1913.

———. *Tarry Breeks and Velvet Garters.* Toronto: Roberson Press, 1958.

Townsend, Robert B. *Tales from the Great Lakes Based on C.H.J. Snider's "Schooner Days."* Toronto: Dundurn Press, 1995.

————. *When Canvas Was King: Captain John Williams Master Mariner.* N.p., 2001.

————. *When Canvas Was King: Quinte and Prince Edward.* N.p., 2002.

Truax, Paul W. *La Force Descendants in North America.* N.p., n.d.

Van Cleve, Captain James. *The Ontario and St. Lawrence Steamboat Company's Hand-book for Travelers.* Buffalo, NY: Jewett Thomas and Co., 1852.

————. *Reminiscences of the Early Period of Steamboats and Sailing Vessels on Lake Ontario, with a History of the Introduction of the Propeller on the Lakes.* N.p., 1877.

www.maritimehistoryofthegreatlakes.ca.

About the Author

S usan Peterson Gateley sails and writes on Lake Ontario. She has a science background and worked as a fisheries biologist and high school science teacher before taking up writing and publishing. Find her online at www.silverwaters.com.

Other books in print by Susan Peterson Gateley

Ariadne's Death: Heroism and Tragedy on Lake Ontario
Descriptions of some of the most dramatic shipwrecks, exciting rescues and really close calls on Lake Ontario between 1840 and 2002. Captain Horatio Nelson Throop, a hero who died in bed; the mysterious Captain Smith, who turned up in Oklahoma years after his ship sank; the phantom barque; and the heroic beer cooler will keep you turning the pages.

The Edge Walker's Guide to Lake Ontario Beach Combing
This book contains information on lakeshore geology, marshes, wildlife and seasonal highlights for hikers, beachcombers and canoers—a guide to two dozen public beaches, parks and wildlife management areas along Lake Ontario's shore between Rochester and Watertown.

Living on the Edge with Sara B
Just because it can be done doesn't mean it should be done. But when an unexpected inheritance lands in the author's mailbox and is spent on eBay for an elderly small schooner, a journey ensues and the adventure begins.

Passages on Inland Waters

Jesuit journeys to save souls, a widow's wilderness flight, sailing through Lake Ontario's perfect storm and a journey on the old Erie Canal are among the varied passages you'll find in this collection of historic and modern-day voyages made aboard a variety of vessels. Maritime history and contemporary yachting alike are featured, along with a section of early twentieth-century photos on and by Little Sodus Bay.

Twinkle Toes and the Riddle of the Lake

In this story for the young and the young at heart, a crabby cat, a lousy navigator and an old wooden boat journey to Canada to find answers to a mysterious disappearance. The book includes an extensive appendix of recent environmental events and emerging issues relevant to all the Great Lakes.